pictures without borders

bosnia revisited

First published in the United Kingdom
in 2005 by

Dewi Lewis Publishing
8 Broomfield Road
Heaton Moor
Stockport SK4 4ND
England

www.dewilewispublishing.com

© 2005
for the photographs: Steve Horn
for the texts: Steve Horn and Helen Walasek
for this edition: Dewi Lewis Publishing

ISBN: 1-904587-20-8

Maps: courtesy David Fisher and University of Texas Libraries,
University of Texas at Austin

Design and production: Dewi Lewis Publishing
Print: EBS, Verona, Italy

www.pictureswithoutborders.com

pictures without borders

bosnia revisited

steve horn

dewi lewis publishing in association with The Bosnian Institute

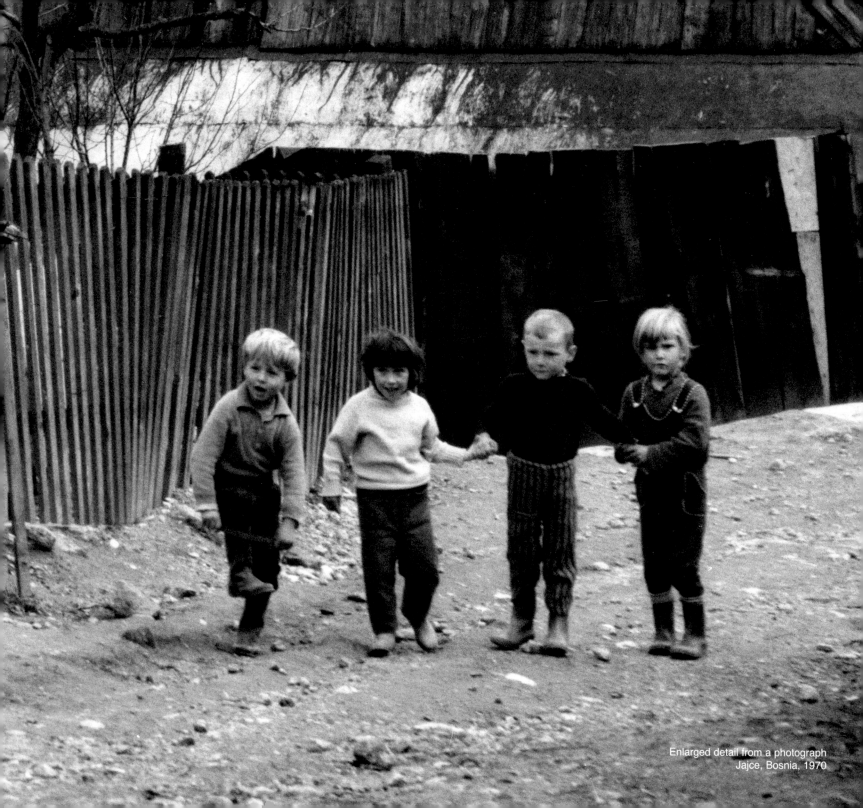

Enlarged detail from a photograph
Jajce, Bosnia, 1970

FAX
Sarajevo 11 November 2003
TO: Dr. Senada Del Ponte

Dear Dr. Del Ponte,
I am an American photographer and photographed a group of children in Jajce, Bosnia
33 years ago. You were one of those children, the others were Šefika, Jef and Samir.
I would like to send you a print and perhaps write by email. Please contact me. My
traveling email address is below.
With best wishes,
Steve Horn

EMAIL
12 November 2003

Dear Mr. Horn,
I am so happy for your fax. I was crying like a child when I read it. This is for
me like a small miracle because I haven't any pictures of my childhood. I am not
very good at English but I would like to keep contact with you. I would like to hear
your story about your visit to my city.
I send you dear salutation,
Senada Del Ponte

Dedicated to
Aida, Samir, Šefika, Senada, Vernes, and their families,
and to Edo, Erzad, Mario, Suad, and Taida,
who linked the past with the present.

INTRODUCTION

It was my first day back in Bosnia. I woke to the sounds of church bells, calls to prayer from minarets, busy street traffic. The early-morning light slanted across the far hills, the sky was deep blue. Rising out of bed, I stood before the window. Here at last, I thought. Something

felt familiar, yet different – magnified many times by the effects of war.

Being a photographer makes travelling light an ambition but never a reality. Beside the bed were my clothes and my equipment: two film-based cameras, a small tripod, plenty of film, a camera bag, a digital camera, and a portable printer for giving away photos. At the last minute I had also added a digital audio recorder. And then there was all the winter clothing, since it was already late October and Bosnia is a mountainous country. I also carried photographs from my visit over thirty years earlier – images seeking a passage home, and I was their designated courier.

When I prepared for this return to the Balkans, I had fears for my safety. I'd read accounts of the wartime horrors, and of the land mines – and I knew only a few words of tourist Bosnian. Yet, despite my fear of the unknown, I felt compelled to go.

Questions about how the country and the people were coping in the aftermath of war were what drew me. And I wanted to show the old photographs to those for whom they would have meaning.

Thirty years ago I went on my first trip to Bosnia. A student at Amherst College in Massachusetts, I was taking a year abroad to do field study for my thesis. It was the time of the Vietnam War – a war being fought by my government, with which I strongly disagreed but felt powerless to affect. The threat of nuclear war seemed to loom large. To me the world seemed out of control. I believed that America was capable of providing freedom, hope, justice, tolerance, opportunity, and good deeds internationally. Why then was my country choosing war?

This question compelled me to travel abroad with the intention of documenting and preserving the spirit of place. I wanted to build a body of work with a common theme, one that spoke to traditional life and its presence in many forms.

In the former Yugoslavia the connections I made with individuals, the mix of cultures and architecture, and the beauty of the country affected me deeply. I realized that the tradition I sought was fragile and at risk, because it didn't conform to the encroaching modern advances and was rapidly losing ground.

I wanted to document those places that were rarely photo-graphed – not postcard images. I believed many sites were in danger of being forgotten, paved over, or left to crumble. At that time I did not envision war in Yugoslavia, which made

me grieve all the more later when lives were lost and the fabric of a society I had been drawn to was torn apart.

Later, I exhibited some photographs at Amherst. Then for many years I stored the negatives. They sat in a binder, waiting to come to light and be shared again.

In April 1992 accounts began to appear that the war was spreading into towns and cities I had visited. As the reports

worsened, I began to think of the people I had met on that first trip. There was a profound disconnect between my memory of Bosnian hospitality and the current reality of war.

In August 1994 I printed pictures from the former Yugoslavia for a benefit event set up to raise funds for the Bosnian Student Project, a program that brought war-displaced Bosnian students to schools in the United States. Several of these students visited our community to speak about their personal experiences. Hearing their stories, and sharing the images I'd printed, was the beginning of my reconnection to Bosnia.

The US-led invasion of Iraq began in March 2003. As in Vietnam, America was once again waging an unpopular war in a distant land without the support of the international community. During that time of terror alerts and the creation of the Patriot Act and Homeland Security Administration, I watched a growing emphasis on fear-based actions. I had already been contemplating a trip back to Bosnia. These new developments reinforced the urgency of connecting across borders, of reaching out in friendship at a time of increasing American isolation.

I was also driven by my instinct to share the earlier pictures with people who had been cut off from their past. I had photographed a group of children playing high up on a hill in the historic Bosnian town of Jajce. On my return I found two of those children, now adults with families of their own. The photographs became their only childhood pictures. I began to see that the deepest significance of the trip was in bringing pictures back to Bosnia, not taking new ones away.

Finally, I had a sense of completion – my photographs had reached their true destination. Not as art, but as stories of life – as testaments to people and places whose identity was threatened.

Bosnia is the shorthand to refer to the full country name, Bosnia-Herzegovina (or Bosnia and Herzegovina). A Bosnian Muslim is now referred to as a Bosniak, though I sometimes still use the former term when describing an historical event or where the new name may be confusing.

Bosnia is comprised of two administrative 'entities', the Federation of Bosnia-Herzegovina and the Republika Srpska (RS). I focused on where I travelled before, which is now entirely within the Federation.

The republics of the former Yugoslavia are now five independent countries: Bosnia-Herzegovina, Croatia, Macedonia, Serbia and Montenegro, and Slovenia. Kosovo is striving for independence but has remained a United Nations Protectorate since the Kosovo War ended in 1999.

Helen Walasek of The Bosnian Institute provides a background on five Bosnian towns and cities in the last section of the book. Additionally there are resource listings and brief biographies of my Bosnian guides.

Bosnian, Serbian, and Croatian languages are very similar. The Latin alphabet is used in the Federation and the Cyrillic alphabet is used in the Republika Srpska. A brief guide for pronouncing names that appear in the story and captions:

a	like the a in art
e	like nest
i	'ee', like street
o	as in okay
u	as in lute
c	'ts' as in sheets
ć & č	'ch' as in cheese.
š	'sh' as in show
ž	'zh' as in pleasure
j	pronounced y, like yes

Sometimes an 'r' appears with multiple consonants and no vowel. In these cases the 'r' becomes a partial vowel, pronounced 'er'. Generally one of the syllables of a word is stressed, but never the last syllable.

Examples:
Jef (Yef)
Jajce (*Ya*-yts-eh)
Stolac (*Sto*-lats)
Šefika (Sheh-*fee*-ka)
Vrbas River (*Ver*-bas)

CENTRAL BALKAN REGION

A BALKAN PORTFOLIO

1970-1971

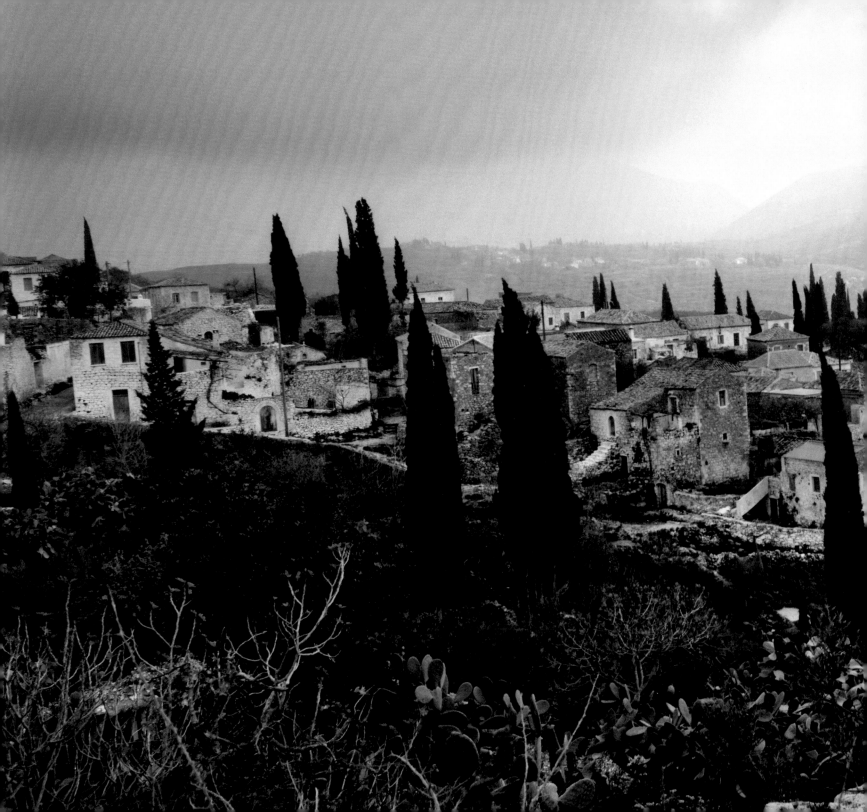

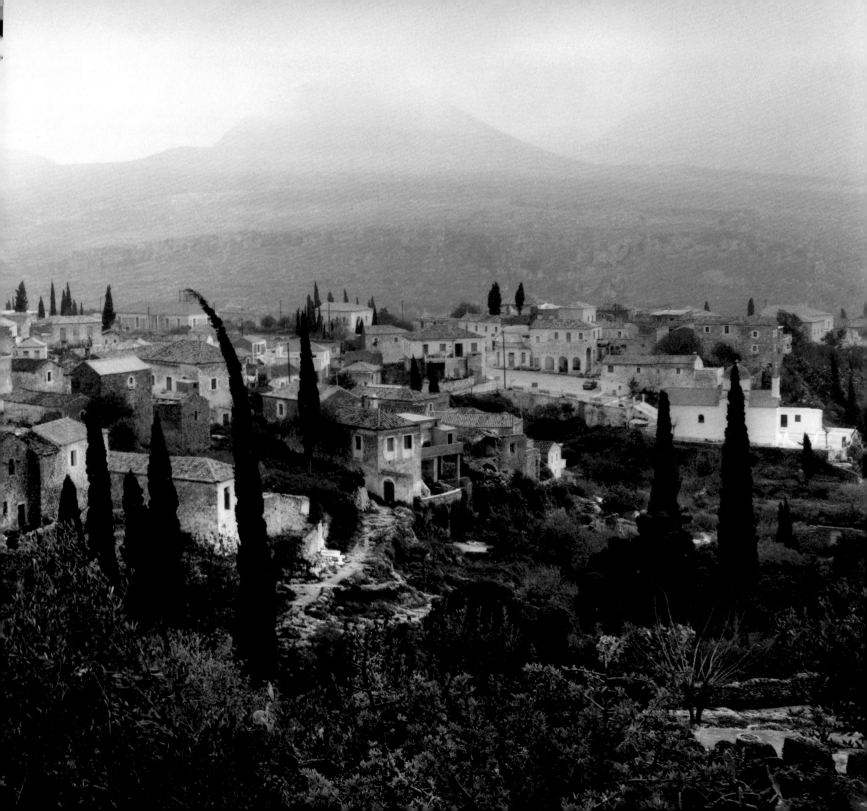

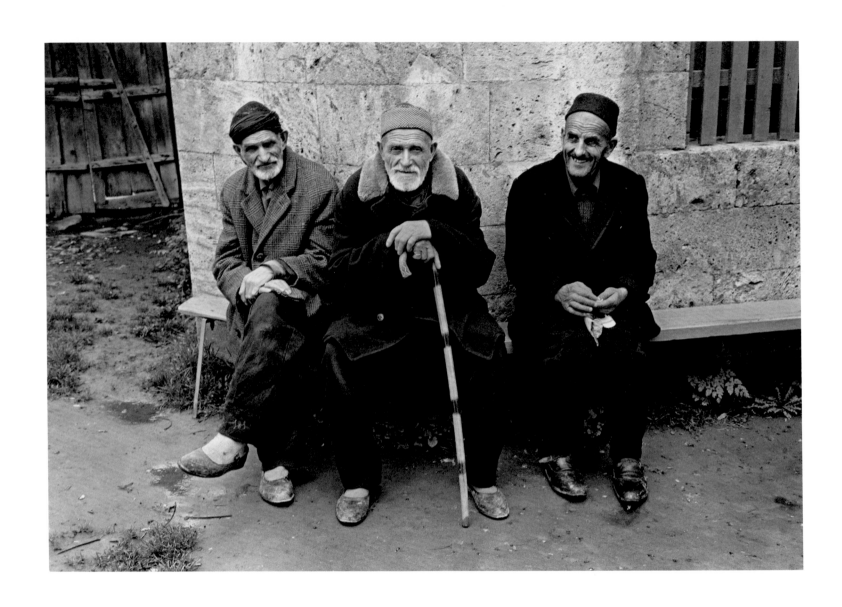

above: Elders in Tetovo, Macedonia, 1970
right: Šipka, Bulgaria, 1970
previous page: Oitylo, Peloponnese region, Greece, 1971

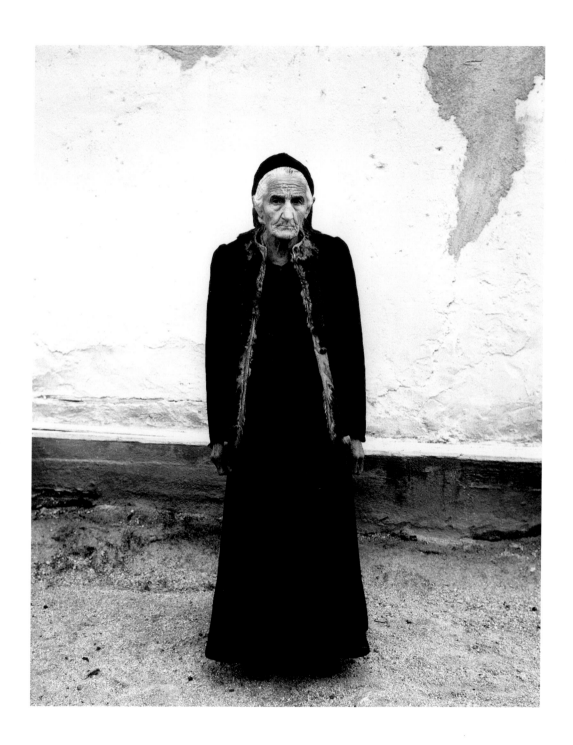

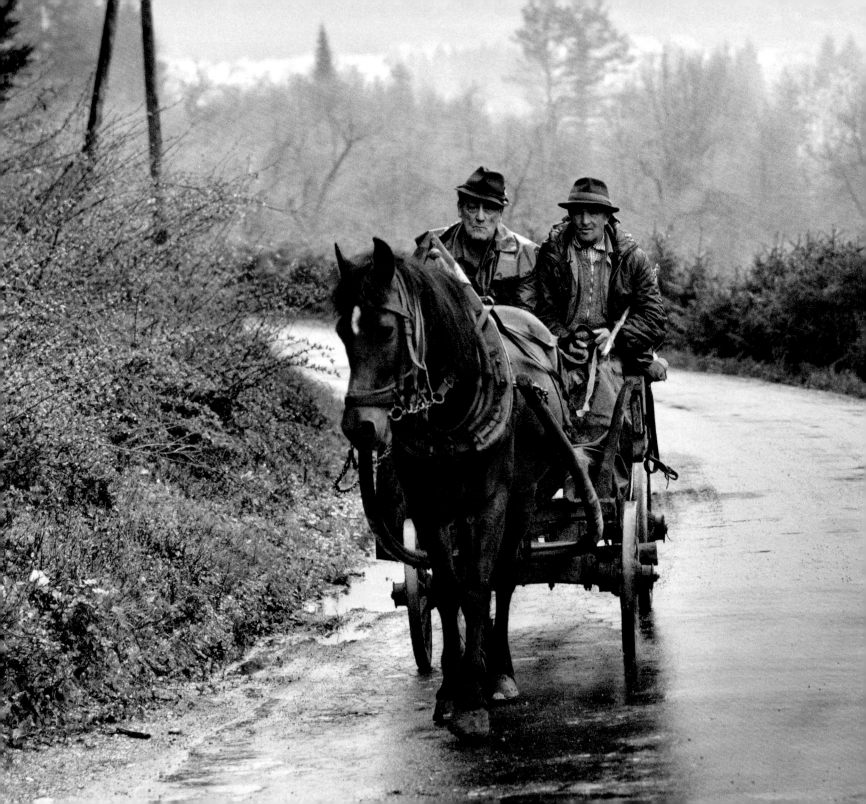

Slovenia, 1970

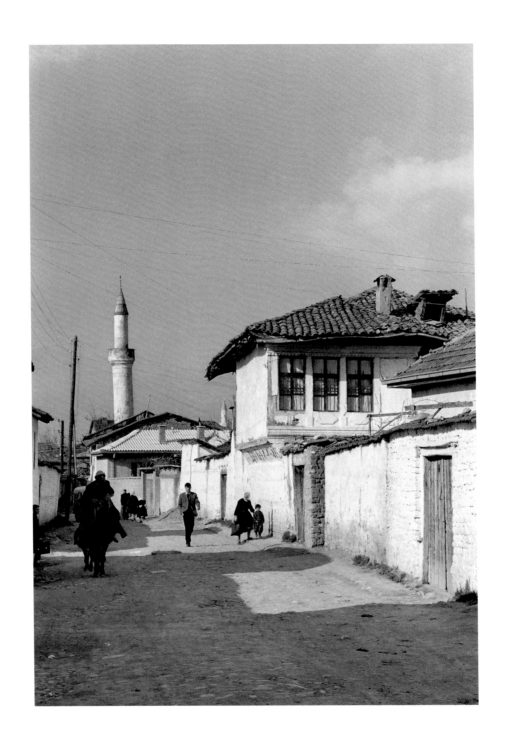

Prizren region
Kosovo, 1971

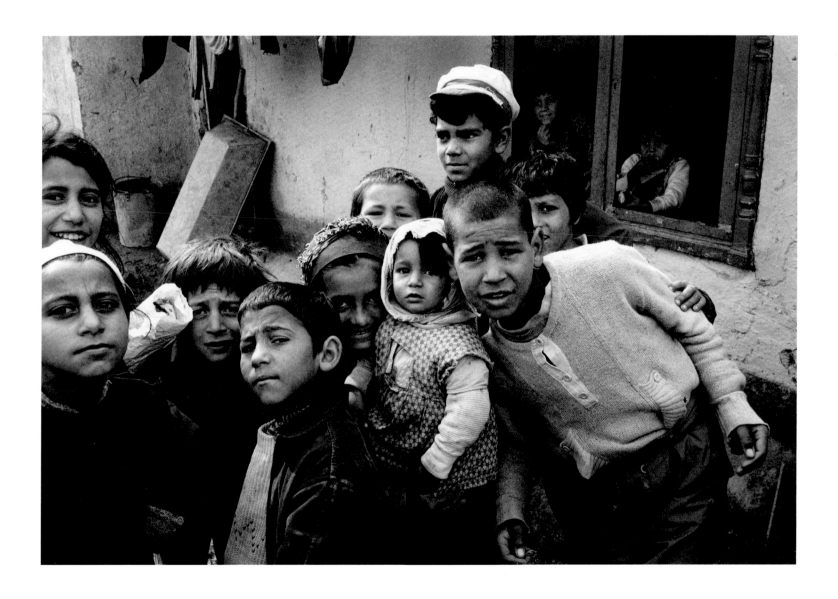

Prizren region
Kosovo, 1971

Leškovac, Serbia, 1970

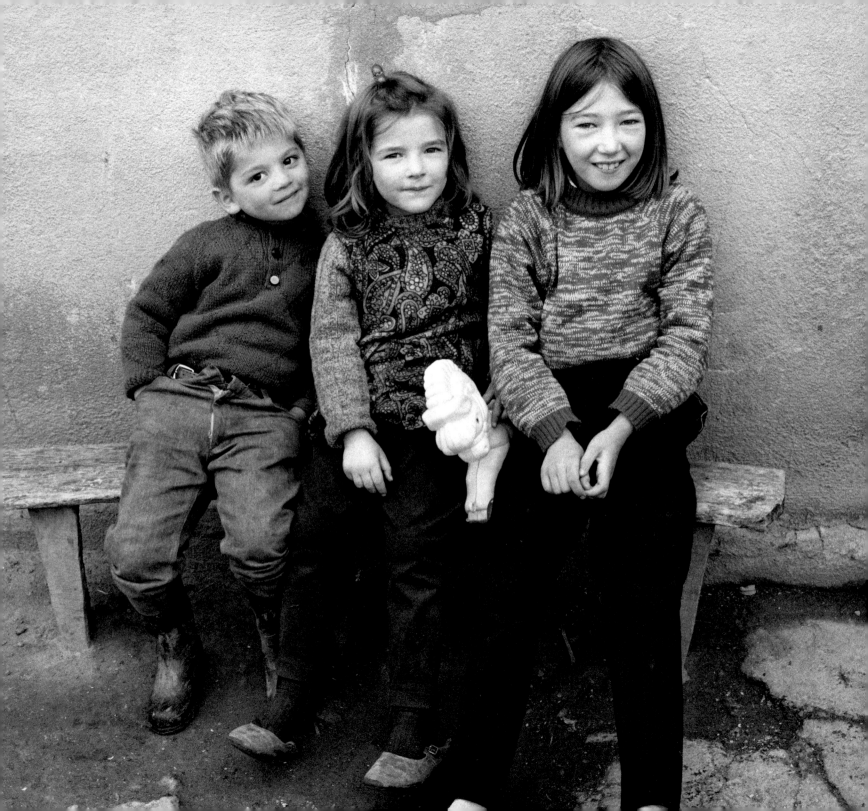

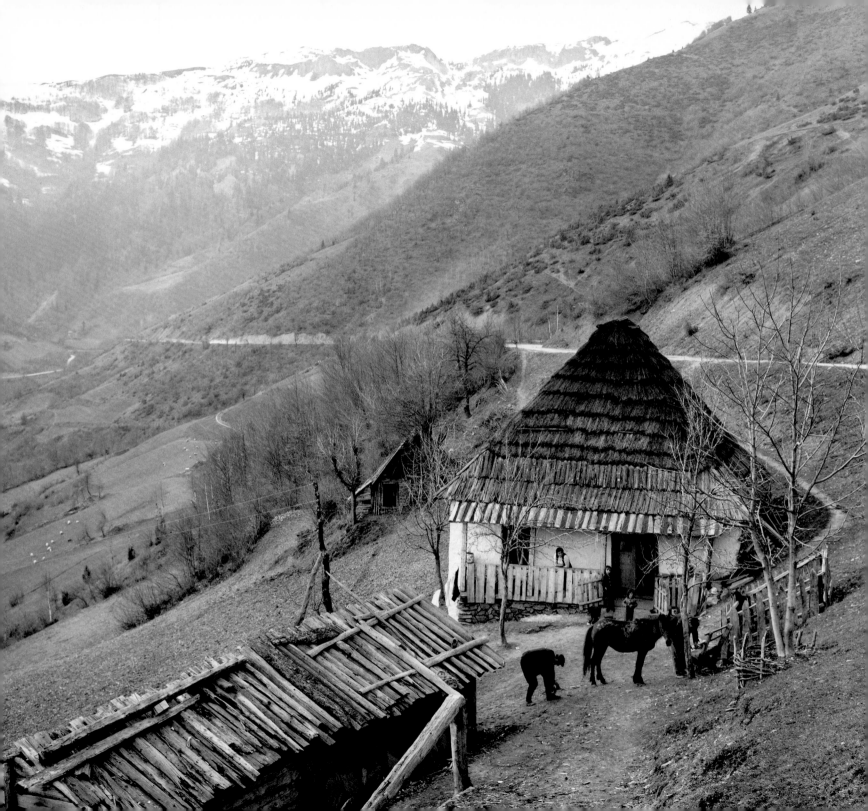

Near Andrijeva, Montenegro, 1971

Tara River Valley, Montenegro, 1971

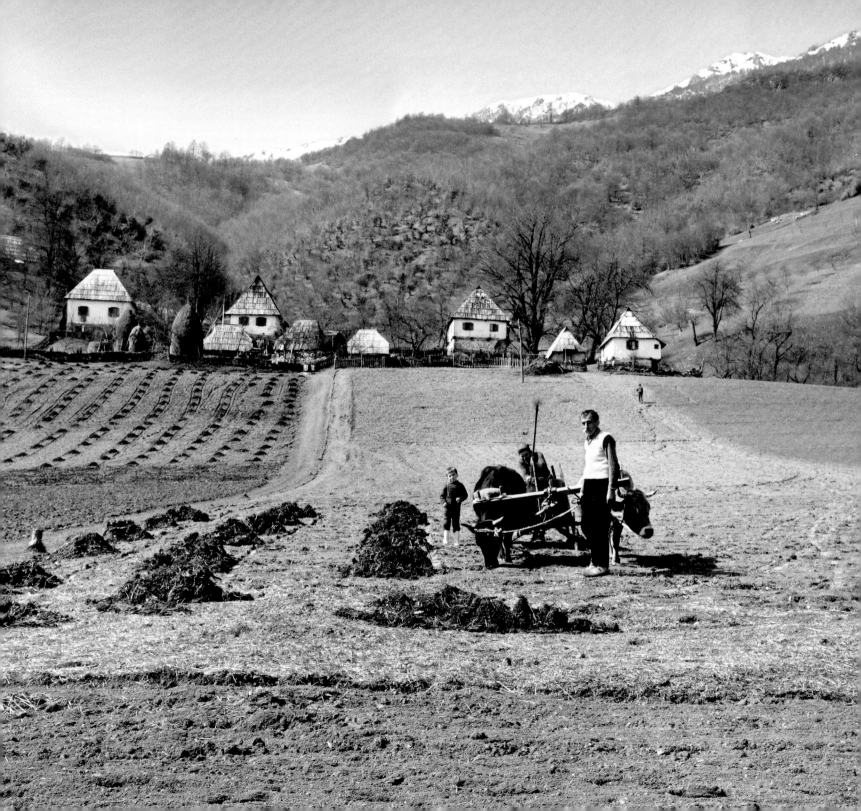

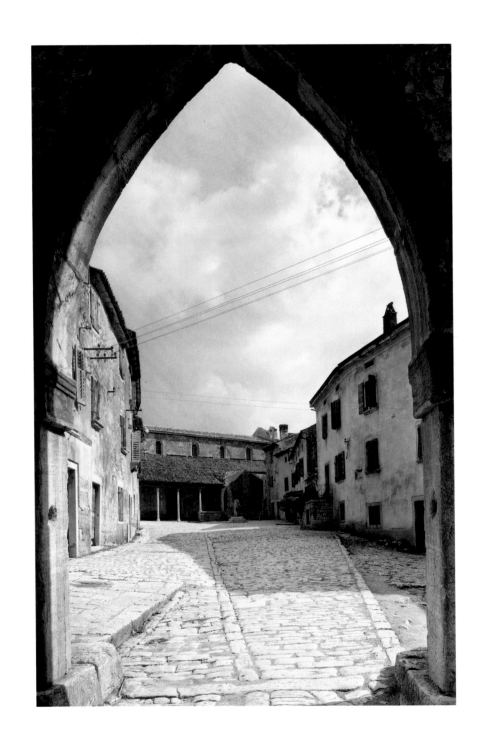

Lovreć, Istrian Peninsula
Croatia, 1971

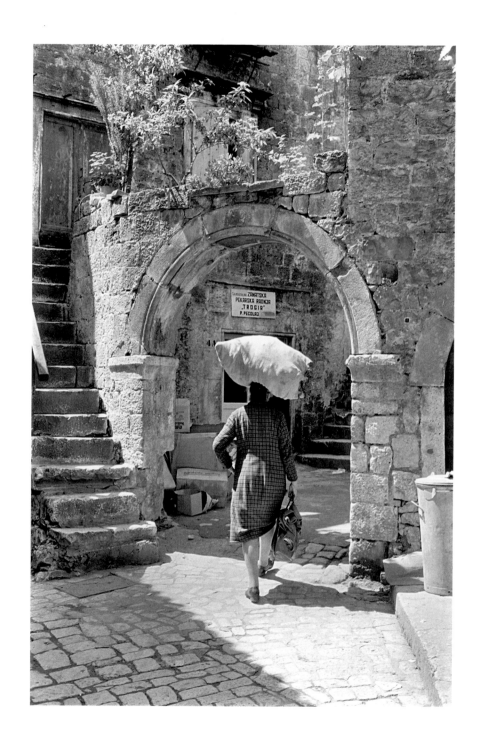

Trogir
Croatia, 1971

right: Šebilj Square, Sarajevo, Bosnia, 1970
next page: Leškovac, Serbia, 1970

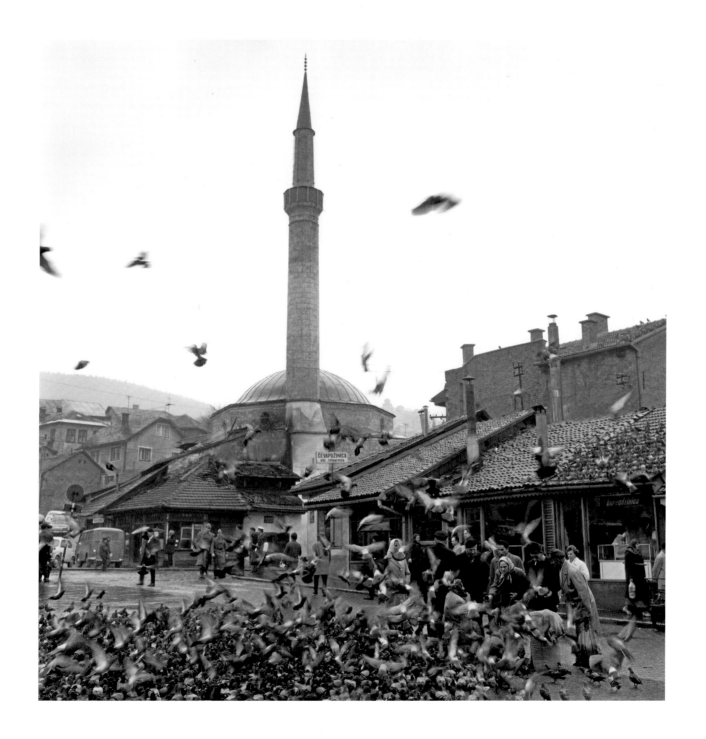

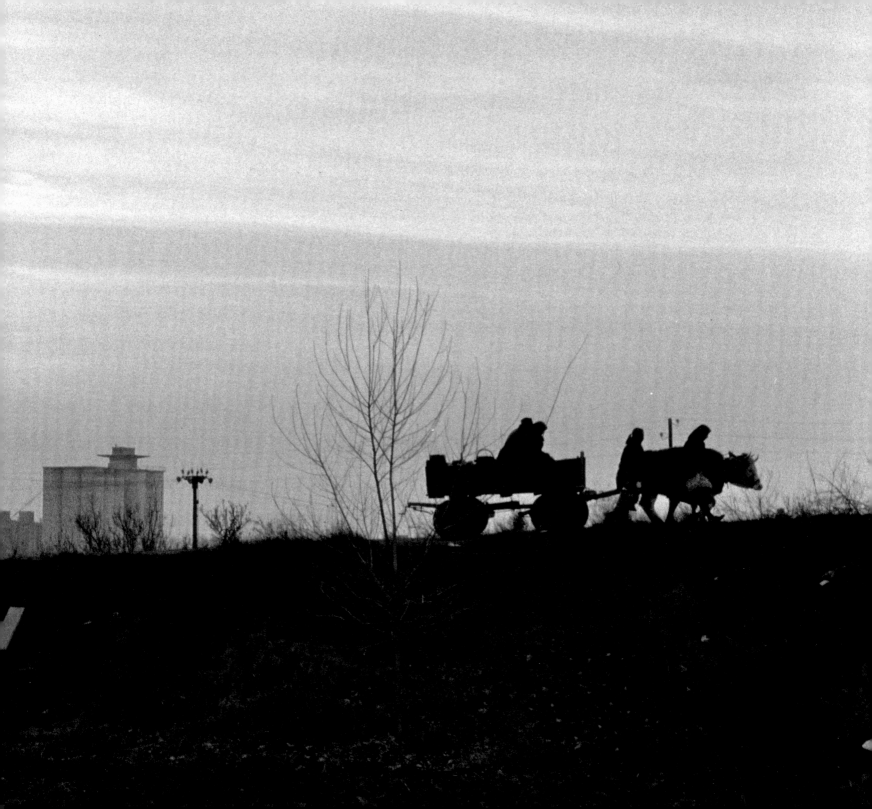

Present-day Bosnia-Herzegovina was the site of rich Neolithic and Illyrian cultures in the 3rd to 1st millennia. In the 3rd century BC, Bosnia became part of the Roman Empire and remained so until its division in 395 AD. Most Bosnians are descendants of Slav tribes who settled in the region during the 7th century. A common language developed, and by the early medieval period Bosnians had adopted Christianity. Reflecting the region's split between Byzantium and Rome's Western successors, many inhabitants of Bosnia became either Eastern Orthodox (later known as Bosnian Serbs) or Roman Catholic (later known as Bosnian Croats); a separate Bosnian church also grew up.

Nominally under Hungarian authority, Bosnia became an independent kingdom by 1200. During the 14th and 15th centuries Bosnia's territory underwent significant political and territorial expansion. Trade and silver mining developed, and towns and castles were built. Culture flourished, particularly in the areas of manuscript illumination and metalwork, as well as Bosnia's most legendary symbol, the monumental decorated tombstones called *stećci*.

By the mid-15th century most of Bosnia became part of the Ottoman Turkish Empire, and many Bosnians converted to Islam, probably because of their weak allegiance to any particular form of Christianity. Those who remained Christian were allowed freedom of worship but were subject to taxation and restricted from participating in politics or the military.

Turkish rule continued for four hundred years. Bosnia was the Ottoman Empire's border with Western Europe and by the 17th century Sarajevo was the second-largest city in the Empire. Towns and cities developed a tolerant mix of Muslim Bosniak, Catholic Croat, Orthodox Serb, and Sephardic Jewish cultures. Many architectural masterpieces were constructed: mosques, bridges, schools, inns, clock towers, and baths.

As the Ottoman Empire disintegrated, in 1878 Bosnia fell under Austro-Hungarian control. A Western European way of life and new styles of architecture took hold; railways and industries developed; and new public buildings, parks, and schools appeared. The annexation of Bosnia by Austria-Hungary fuelled a growing Serbian nationalism. In 1914 in Sarajevo a Bosnian Serb nationalist, Gavrilo Princip, assassinated Archduke Franz Ferdinand, heir to the Austrian throne, an event that triggered the outbreak of World War I. After the war Bosnia became part of the newly created Kingdom of the Serbs, Croats, and Slovenes, later the Kingdom of Yugoslavia.

In 1941 Yugoslavia was attacked and occupied by the Axis powers. Serbia, Croatia, and Bosnia all endured brutal regimes, war crimes, and deeply polarizing ethnic conflict incited by their occupiers. At the same time, Josip Broz Tito's multi-ethnic resistance forces were centred in Bosnia.

In 1943 Tito became leader of a federal Yugoslavia, with Bosnia as one of its republics. At first repressive, Tito later relaxed his grip and promoted the growth and development of

Bosnia's economy, educational system, and infrastructure. With these measures, and by outlawing expressions of ethnic nationalism and restricting religious practices, Tito achieved a degree of unity throughout Yugoslavia.

Yugoslavia's descent into war began with the death of Tito in 1980 and its subsequent economic collapse. In 1987 Slobodan Milošević rose to power promoting Serbian nationalism and Belgrade centralism, which ultimately proved fatal for the federal order and thus the continued unity of Yugoslavia. After multi-party elections Slovenia and Croatia declared independence from Yugoslavia in 1991, and war broke out when the forces of the Yugoslav National Army (JNA), led by Serbia, attacked both countries. Milošević henceforth sought to create a Greater Serbia while Franjo Tudjman stirred up nationalist sentiments in both Croatia and mainly Croat areas of Bosnia-Herzegovina.

Bosnia's mix of Serbs, Croats, and Muslims made it vulnerable to the exploitation of ethnic differences. Both Milošević and Tudjman took advantage of this vulnerability and of lingering animosities from World War II. In April 1992, after Bosnia declared independence from Yugoslavia, war broke out there, and troops and Serb paramilitary units poured over the border from Serbia. Nationalist Bosnian Serbs declared a breakaway Republika Srpska. As Europe, the United States, and the United Nations watched, Bosnia was ravaged and thousands of civilians were killed, raped, or forced to flee. In 1993 Croat separatist troops turned on their

Muslim allies as a result of the Vance-Owen Plan to divide Bosnia into ethnically pure cantons; peace was eventually restored between them in 1994. Despite countless international initiatives and the presence of UN forces, the war continued until 1995, when President Clinton finally sought NATO military intervention in the conflict. The Dayton Peace Accords ended the war in December 1995, dividing Bosnia into two parts: the Federation of Bosnia-Herzegovina, mainly Bosniak and Croat controlled, and the Republika Srpska (RS), mainly Serb controlled. Justified at the time as an interim solution to stop the violence, the settlement is seen by many today as overdue for revision.

The greatest crime committed during the war was the murder of over 7,000 Muslim men and boys after the fall of Srebrenica in 1995. Victims in mass graves are still being identified ten years after the massacre. Tudjman died after the war, but Milošević was brought to trial in the International Criminal Tribunal for the Former Yugoslavia in The Hague as a war criminal. Some key Bosnian Serb leaders indicted for war crimes, including Radovan Karadžić and Ratko Mladić, have remained at large, slowing the process of reconciliation.

In the midst of the rocky and uncertain aftermath of war the Bosnian people continue to rebuild their lives and their communities.

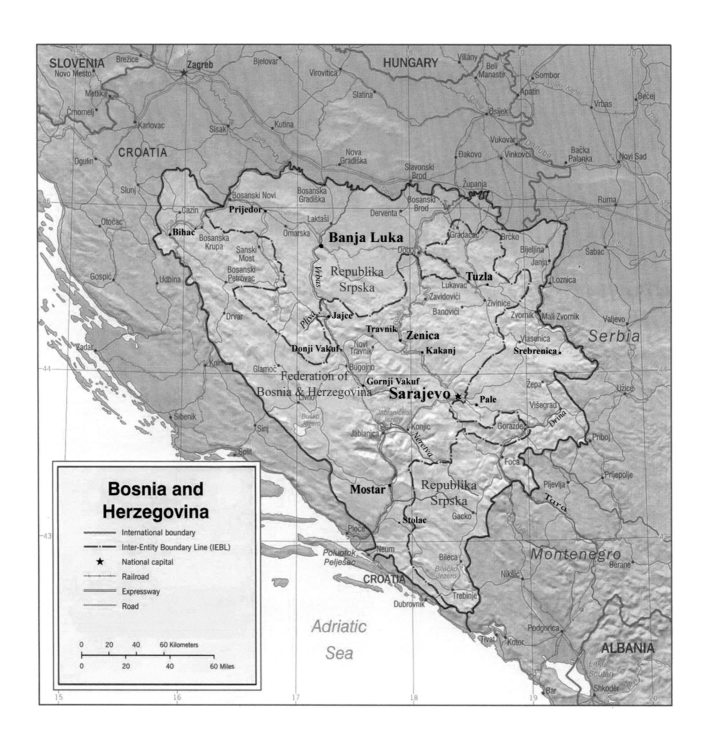

Bosnia and Herzegovina

- International boundary
- Inter-Entity Boundary Line (IEBL)
- ★ National capital
- Railroad
- Expressway
- Road

| 0 | 20 | 40 | 60 Kilometers |
| 0 | 20 | 40 | 60 Miles |

REMINDERS OF WAR, BOSNIA, 2003

Back in Bosnia, I saw evidence of wartime suffering and horror: burned-out buildings, shell and bullet holes, minefields, and endless rows of graves. I heard stories of war. I travelled where unspeakable cruelty had run wild in a country where most people desired peace.

Between 1992 and 1995 an estimated 150,000 people died in the war. Sarajevo was under siege for more than three years. Half of the country's population became refugees or were internally displaced through ethnic cleansing or war operations. Residents of communities were often forced out, and their houses burned down. Thousands of buildings of historical or religious significance were destroyed, often in an effort to eliminate an ethnic group's cultural heritage. These actions occurred in and outside of areas of armed combat.

My guide in Mostar, Suad Slipičević, described scenes of war where thousands of mortar shells exploded in his part of the city (east Mostar) and snipers intentionally wounded people, knowing others would go to their aid. Rescuers and wounded were then shot. Suad's father was killed in front of their home by an artillery attack. Yet with all the tragedy that he had experienced, Suad was committed to reconciliation.

When I visited in 2003, peace was a precious and fragile possession still enforced by NATO peacekeepers. There was great beauty, much devastation, and the lingering shadow of enormous tragedy.

Sarajevo, 2003

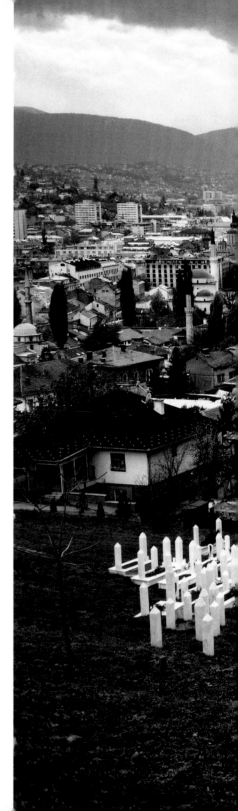

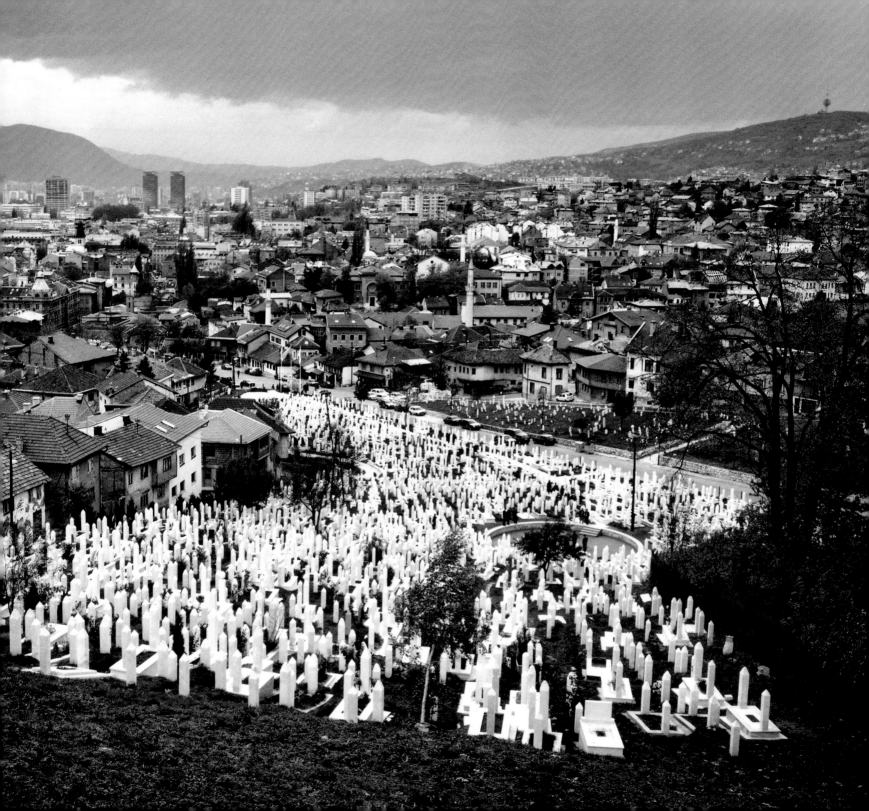

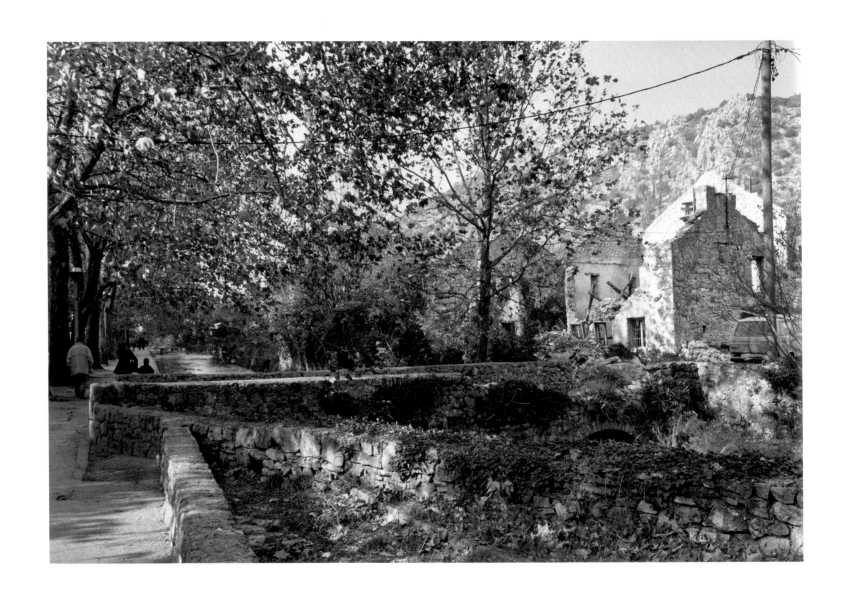

above: Stolac, 2003
right: Elementary school, Mostar, 2003

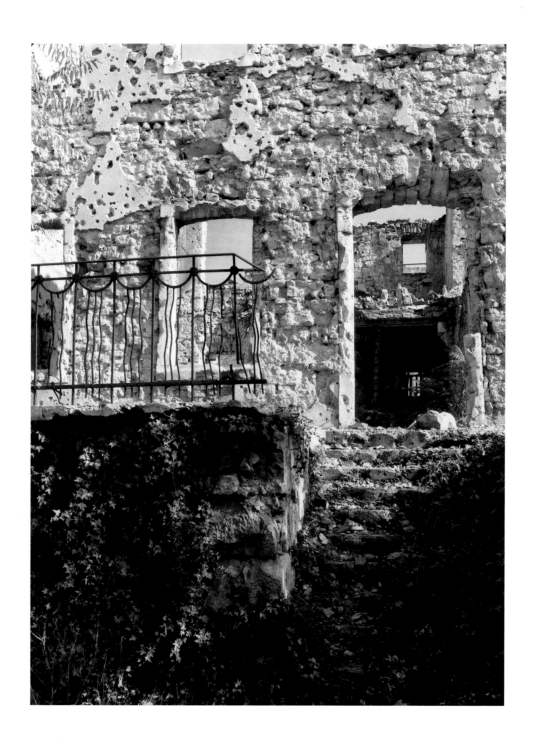

Travnik, 2003

Sarajevo, 2003

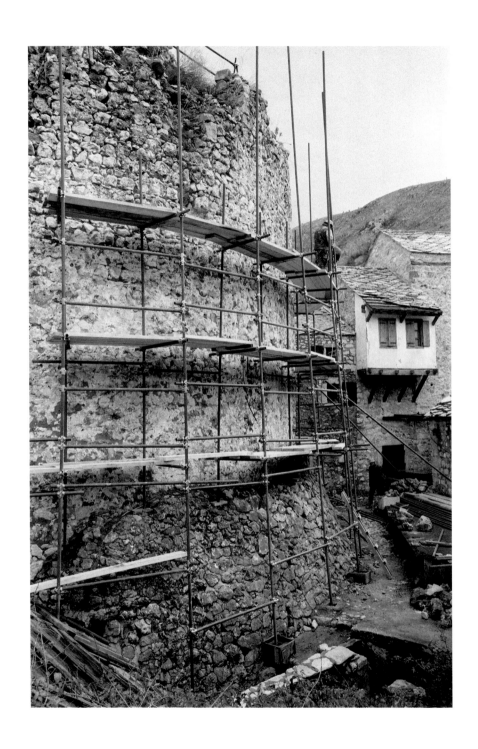

Stari Most reconstruction
Mostar, 2003

Mostar, 2003

Roofing at dusk, Mostar region, 2003

These children were playing in the midst of house and road construction. Their home town, Gornji Vakuf, endured some of the heaviest fighting of the war. The front line shifted through it many times. Their families were still returning and rebuilding when I visited. A local man, hired as a translator for SFOR (the NATO peacekeeping force), told me that during the war many residents lived together in fortified shelters and ventured out only at night, because they were constantly under fire. Snipers shot at anything that moved, even dogs, cats, and birds. When the war ended, there was an eerie silence as people started to return from hiding or from towns to which they had fled.

The man shook his head at the memory. "There were no birds singing in the trees. They had all been shot by snipers."

right: Children in Gornji Vakuf, 2003

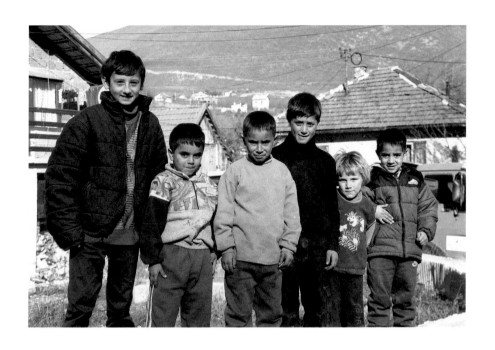

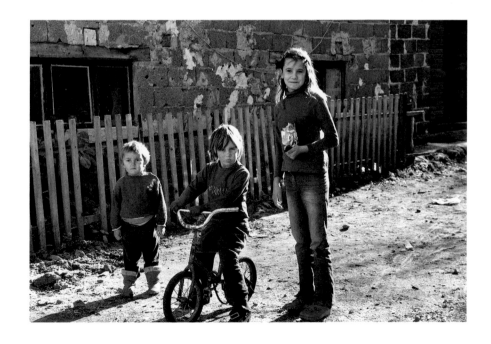

IN A TIME OF FRAGILE PEACE

Bosnia-Herzegovina is a land of beautiful rolling hills, mountains, lakes, rivers, and forests full of wild animals. Its cities and towns have architectural and cultural treasures from many traditions. Thousands of historic buildings were targeted in the war; some survived and many are being rebuilt. Sarajevo, the largest city, prides itself on its history, diversity, and sophistication. Theatre and the arts were kept alive even during its long siege. Rural areas are filled with small villages, some still accessible only by footpath. Many have satellite television, and cell phones are in wide use. Young people are restless for more opportunity. It is a land where Eastern and Western influences – Roman, Byzantine, Venetian, Ottoman, and Austro-Hungarian – came together and intertwined, a country whose diversity is a rich element as well as one of its greatest challenges.

For five centuries Serbs, Croats, Bosniaks, and Jews practised their respective cultural and religious traditions in an atmosphere of tolerance and accommodation. They shared overarching commonalities in their love of family, diversity, and freedom. The war devastated the country and its people, and tore apart the fabric of intermingled cultures. But the commonalities remain. Many Bosnians told me that before the war they did not concern themselves with the backgrounds of their friends and neighbours. Bosnians once lived together in peace, many are learning to do so again, and the political exploitation of ethnic nationalism has diminished.

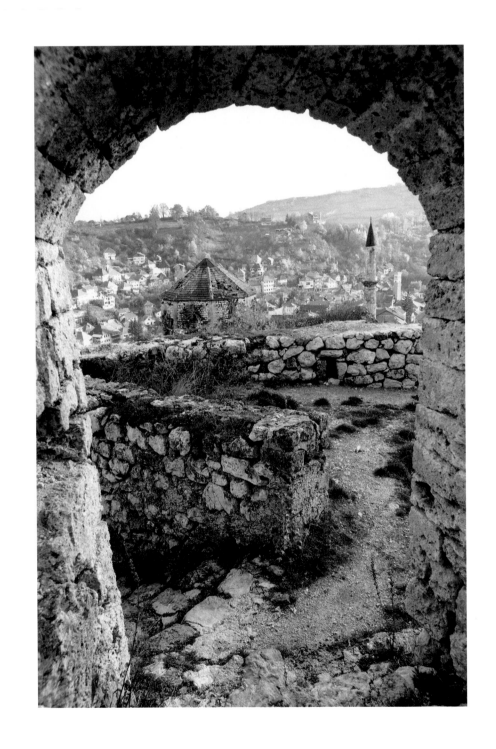

left: Medieval fortress
Travnik, 2003
previous page: Vrbas River
near Jajce, 2003

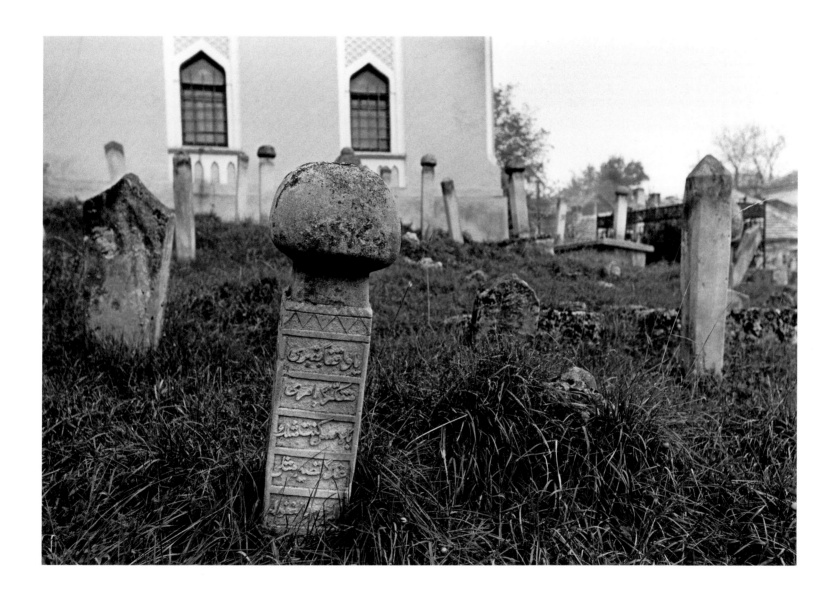

Travnik, 2003

Sveti Luka Chapel in the hills above Travnik, 2003

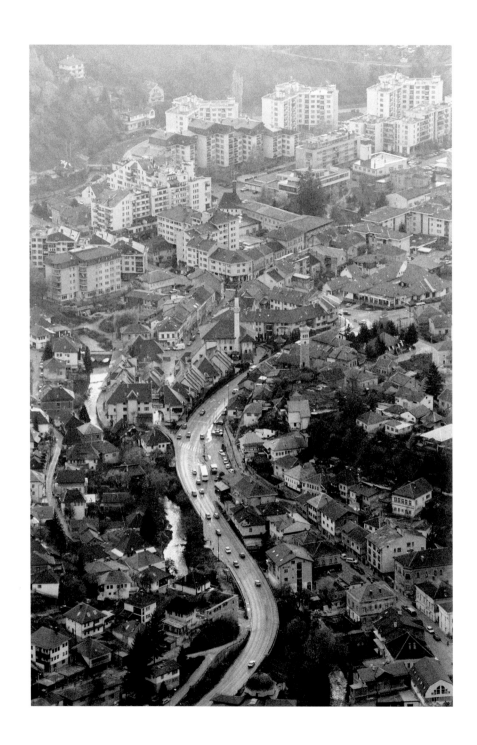

Travnik, 2003

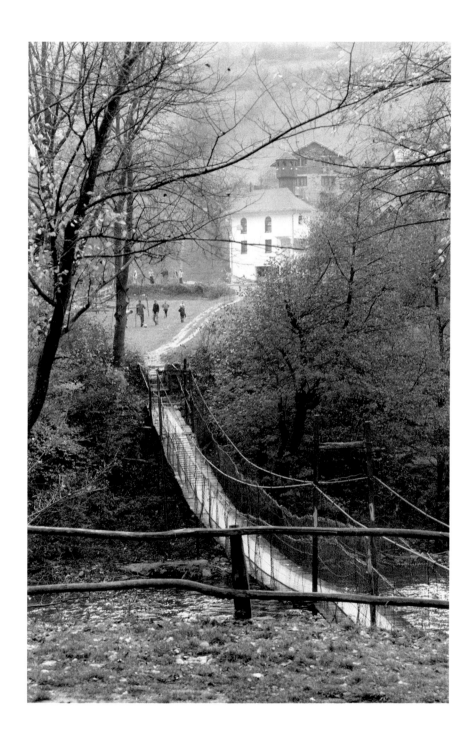

Footbridge across Vrbas River,
near Jajce, 2003

Malo Jezero (Small Lake), Jajce, 2003

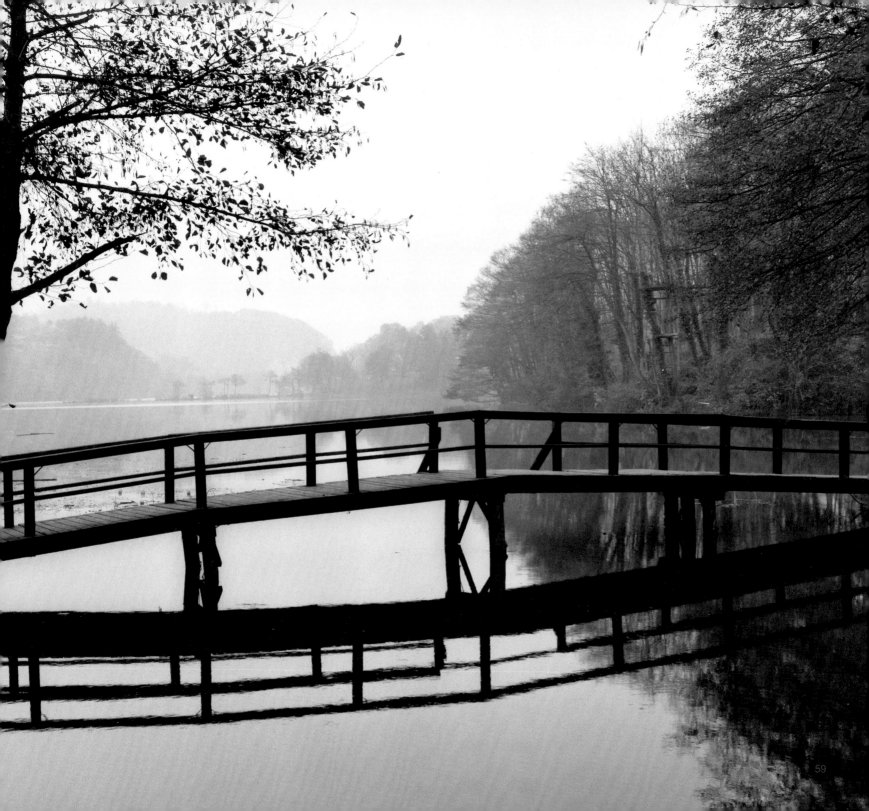

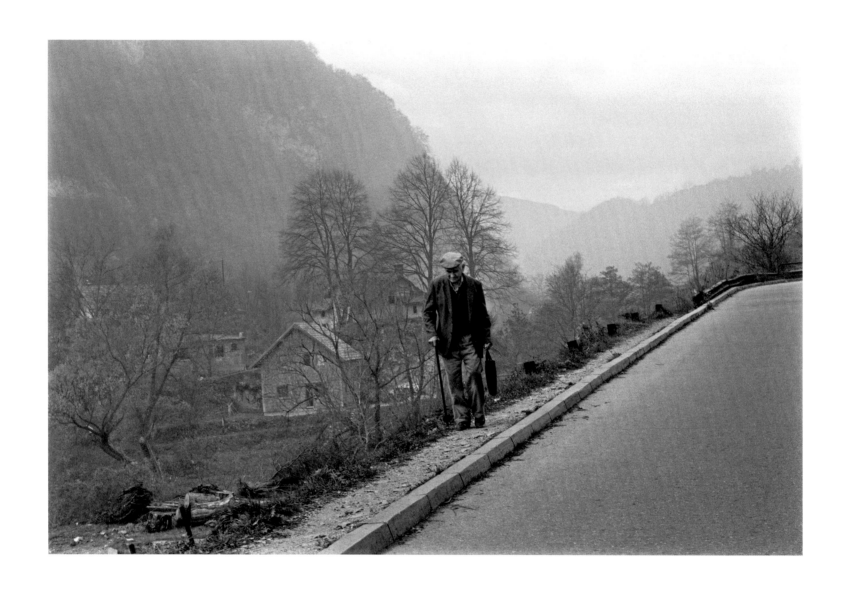

above: Walking to market, Jajce, 2003
right: Stari Grad (Old Town), Jajce, 2003

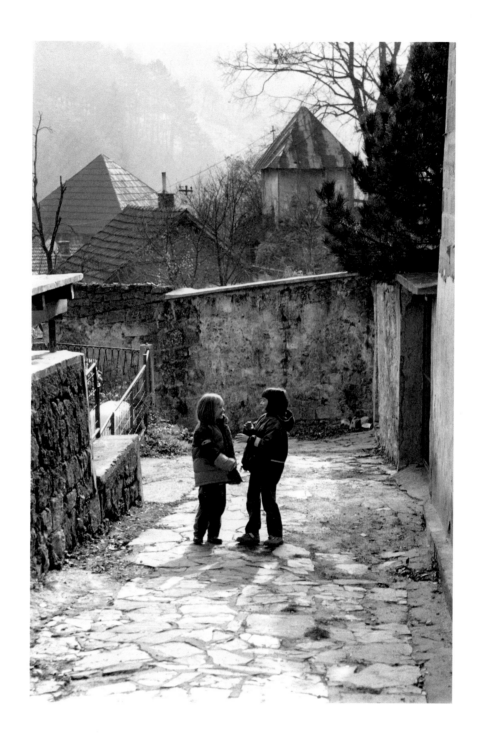

ON CITY STREETS

Journal notes: Mostar, 28 October 2003

Then there are moments like seeing two men playing chess in a public park as early darkness approaches. Behind them lie ruins of the front line mixed with new construction. They concentrate, and laugh, and move their pieces across the checkerboard sidewalk. It is heartening to watch this game being played in the midst of where war once raged.

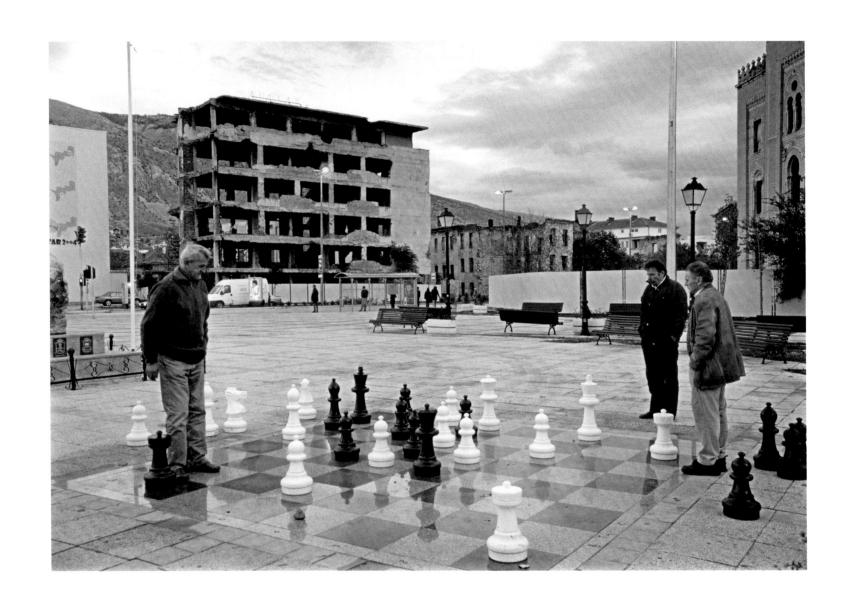

Mostar, 2003

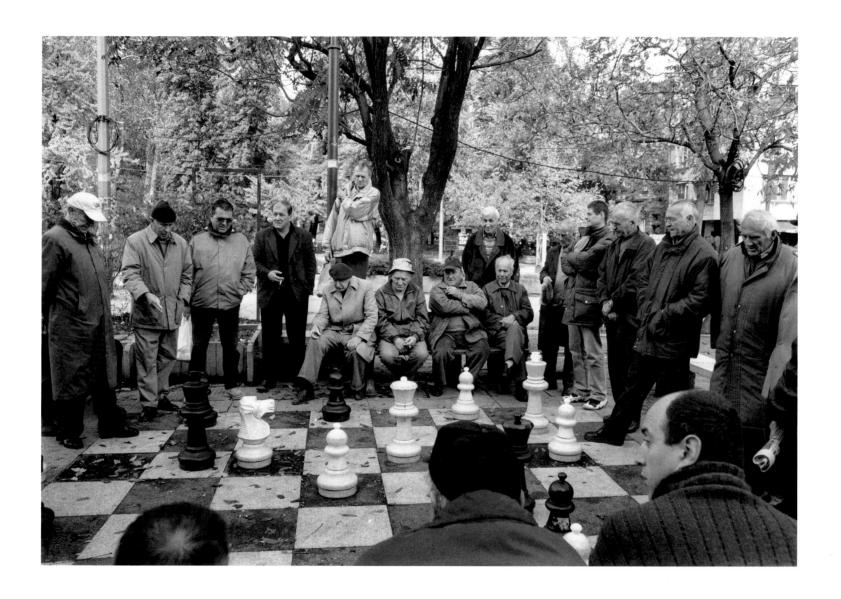

Sarajevo, 2003

Courtyard of the Gazi Husrev Beg Mosque, Sarajevo, 2003

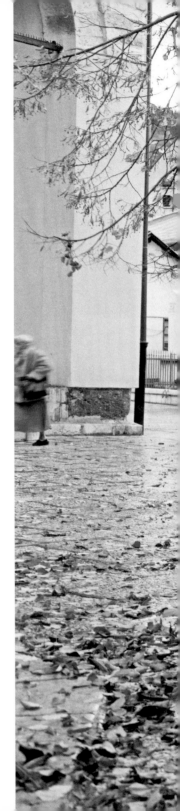

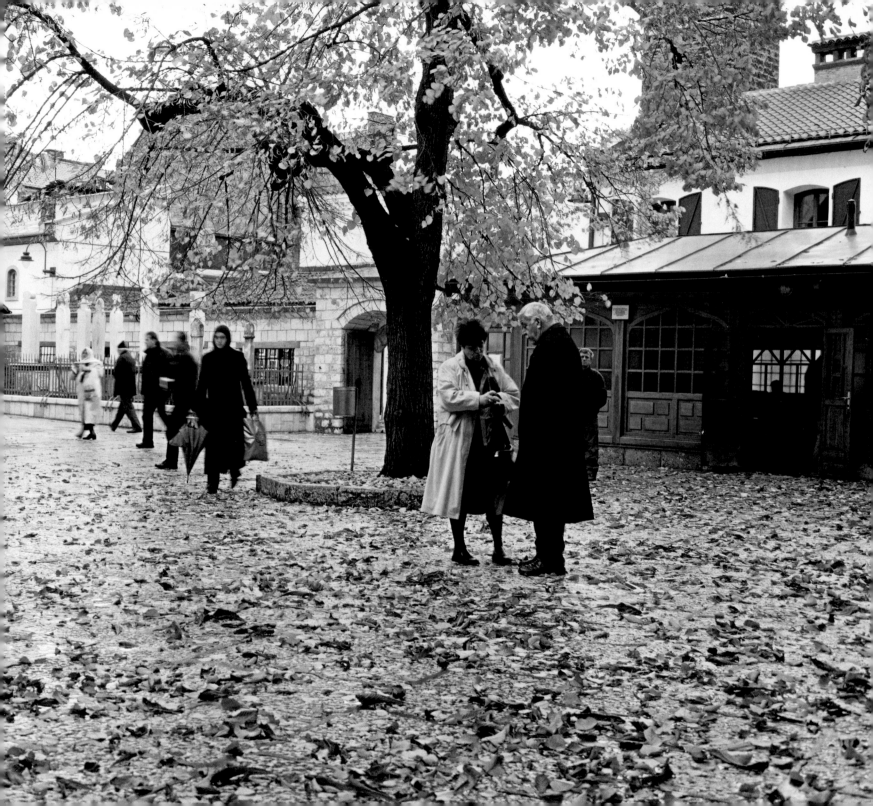

Mostar, 2003

Sarajevo, 2003

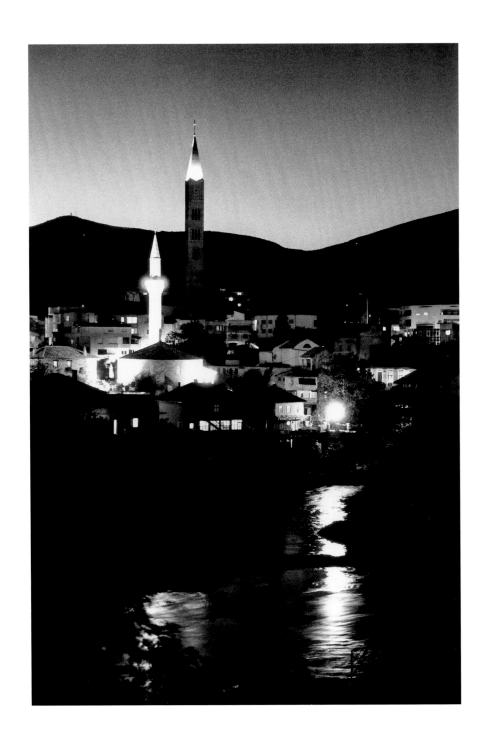

Mostar, 2003

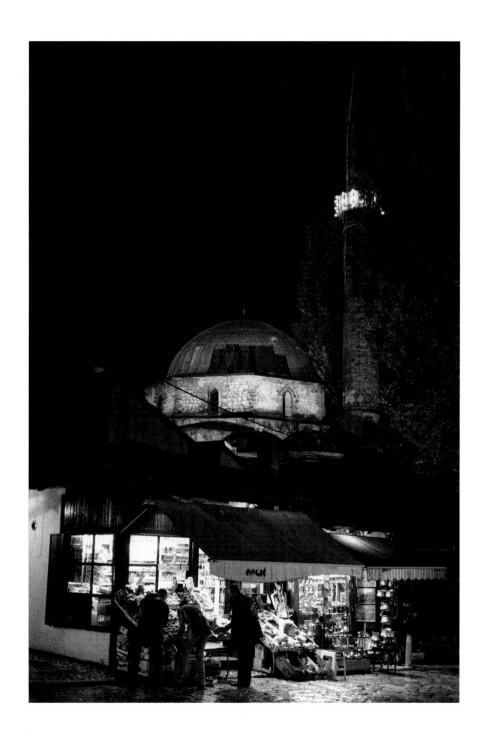

Havadže Duraka Mosque
and produce market
Sarajevo, 2003

Ferhadija, Sarajevo, 2003

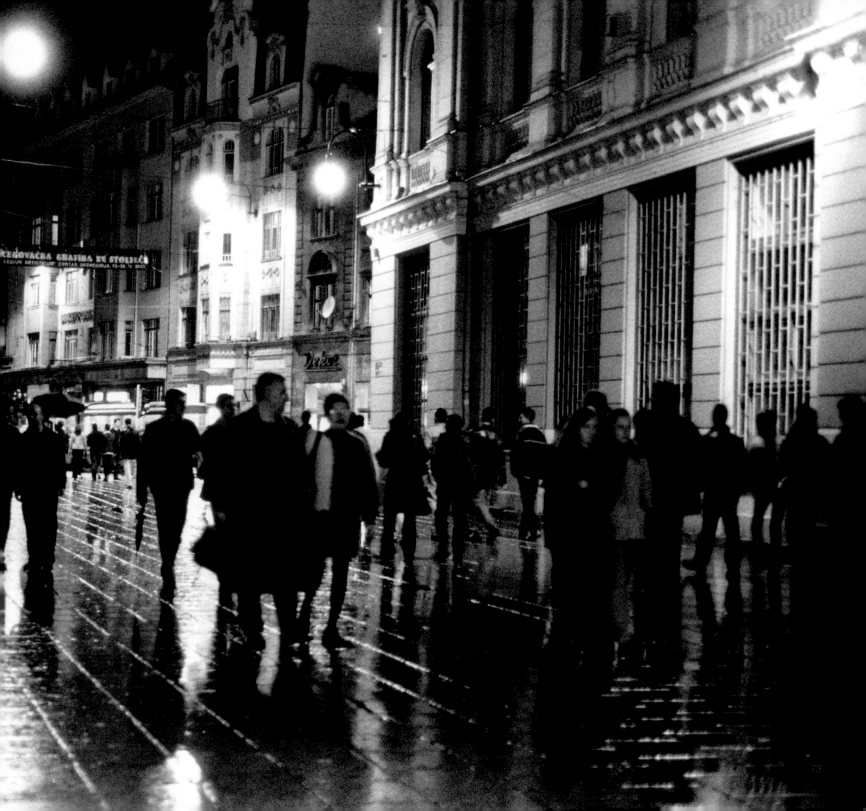

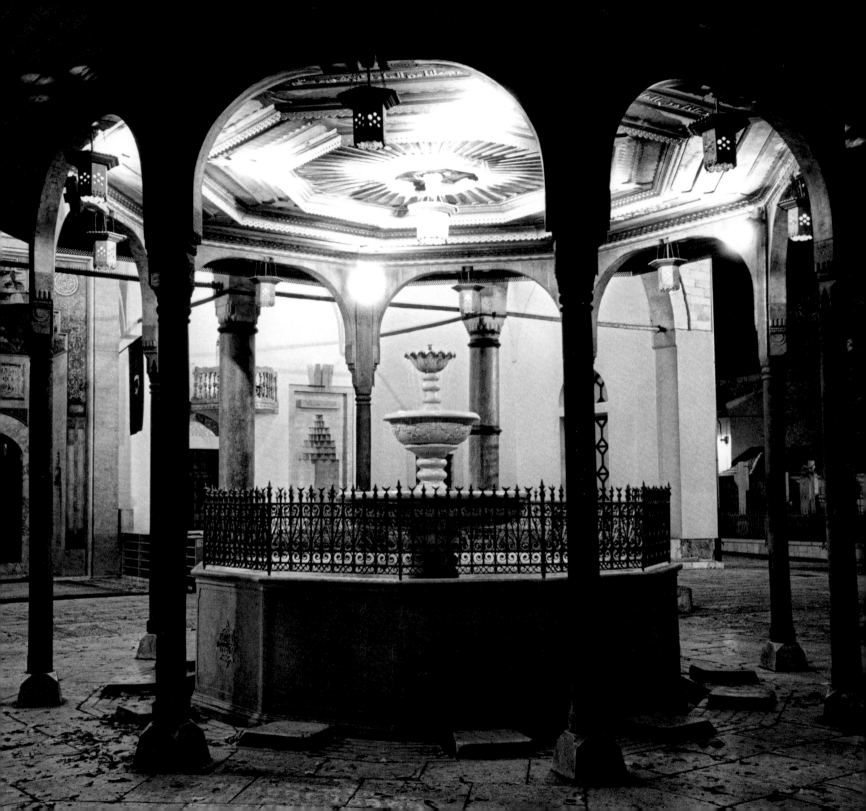

REVISITING PLACES

Journal notes: 31 October 2003

When I reached Sarajevo in the evening, I contacted Taida Horozović, a Bosnian Student Project graduate who offered to guide me around the city. We met and walked to the Old Town. Taida recognized the locations of my 1970 photographs and knew the best routes.

We entered the mosque fountain area. In my hand I held the old photograph. I felt the past and present briefly intersect in an extraordinary way, intensified by the enclosed courtyard of the mosque, which created its own different world, separated by a high wall from the streets and alleys surrounding it.

Gazi Husrev Beg Mosque courtyard with fountain, Sarajevo, 2003
The beautiful courtyard and mosque are among the finest examples of Ottoman Turkish architecture in the Balkans, dating from the 1500s. The mosque was damaged during the siege of Sarajevo and restored in 1996. Some of the original ornamentation was omitted, then later restored after a public outcry.

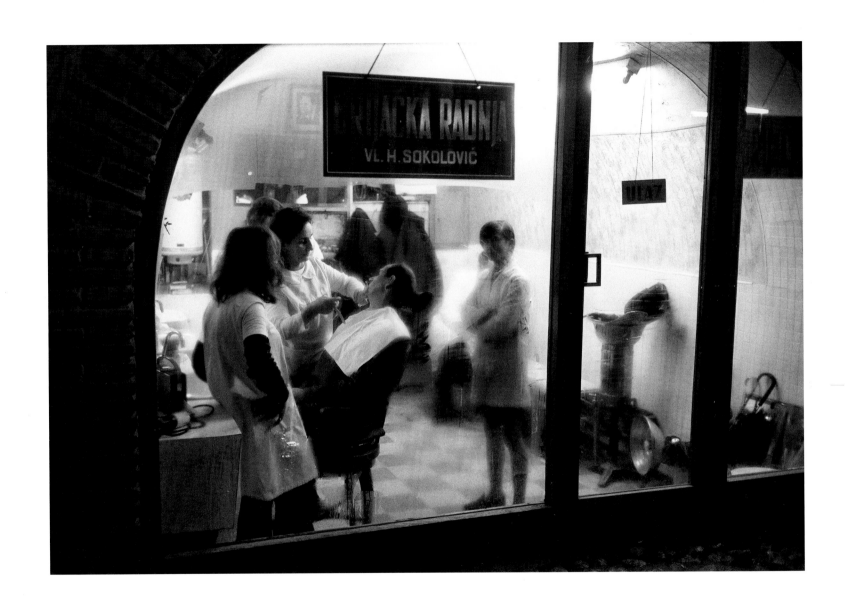

Baščaršija district, Sarajevo, 1970

Baščaršija district, Sarajevo, 2003

Watch sales and repair shop, Baščaršija district, Sarajevo, 1970

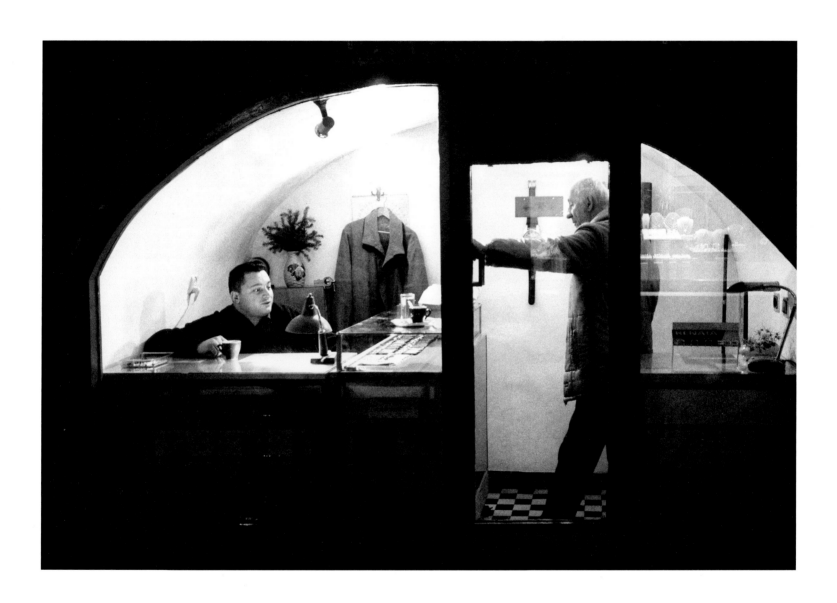

Watch sales and repair shop at the same location, Sarajevo, 2003

During the Ottoman Empire the Turks constructed twenty or more stone bridges in Bosnia-Herzegovina. Twelve still stood when war broke out in 1992. Kriva Ćuprija, the bridge on the facing page, is the smaller of two built in the 16th century in Mostar. It spanned the Radoblje River, a tributary of the Neretva, while the more famous Stari Most crossed the main stream. Together they linked the east and west of the city.

Mostar had enjoyed a long multi-ethnic tradition prior to the conflicts of the 1990s. Serbs, Croats, and Bosniaks lived alongside each other. Their children attended school and played together. The city, with its beautiful setting in the Neretva Valley and its historic bridges and other architectural treasures, attracted visitors from all over the world.

When Bosnia declared independence in April 1992, Yugoslav National Army units from Serbia and Montenegro attacked Mostar. After a two-month siege, Croats and Bosniaks working together drove them back. Then, in May 1993, Bosnian nationalist Croat forces began attacking their former allies. Croats forced Muslims out of the west of the city while heavily shelling the east. By the end of the war, thousands had died and east Mostar lay in ruins. Most Serb residents had already fled the area during the initial Yugoslav army attack.

During the conflict Croat forces targeted and destroyed Stari Most, one of the most beautiful Ottoman bridges ever built. Its destruction was one of the enduring images of the war and provoked worldwide condemnation. Kriva Ćuprija, the bridge pictured here, was damaged by shelling and later washed away in a flood. After retaking the city from Serb forces, Croat extremists also dynamited the Cathedral of the Holy Trinity, the largest Serbian Orthodox church in Bosnia. Both bridges and much of east Mostar's historic core have now been reconstructed. Old bridge stones were recovered from the riverbeds and combined with newly quarried rock, cut by hand. The new Stari Most was opened on 23 July 2004.

When I visited Mostar in 2003, there were still many mixed-background couples, including my hosts. The city was primarily Croat on the west side of the river and Bosniak on the east side. Each used separate school systems, universities, hospitals, and bus lines, even different telephone companies. The night I arrived, my hosts took me out to dinner. As we walked past a building where the scars of war lingered next to fresh renovation, one of them paused, and pointed. "That wall is like Mostar today."

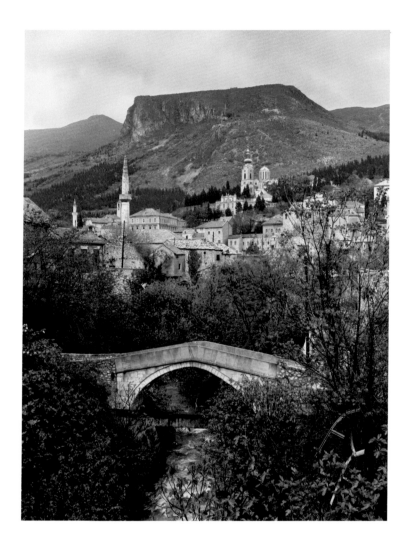

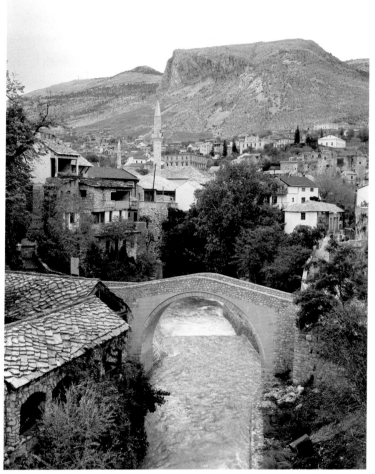

Left: Kriva Ćuprija Bridge and view toward east Mostar, 1970
Most buildings beyond the bridge, including mosques and the Orthodox Cathedral, were destroyed in the war

Right: Kriva Ćuprija Bridge reconstruction and view toward east Mostar, 2003
The government of Luxembourg and UNESCO collaborated on the bridge reconstruction project

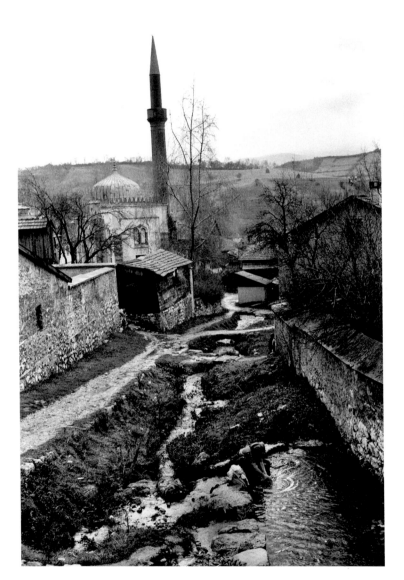

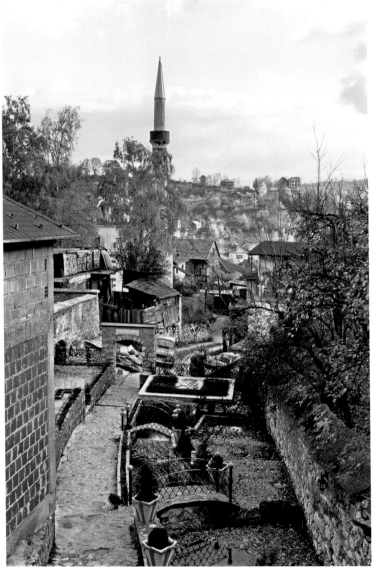

Travnik, 1970

Travnik, 2003

Journal notes: In the mountains near Travnik, 22 November 1970

During the night, in the heaviest wind and rain, I got hopelessly stuck in deep mud. I imagined the VW slowly oozing back toward the cliff edge behind me. There were noises – creaking and bumping – along with the howling wind.

In the morning I began efforts to free it. I created a path of stones behind the wheels, backed onto them, and then drove forward. I moved briefly onto firmer ground, only to get stuck again.

At this point three men in fur hats and sheepskin coats came along. They looked like warriors from another century. I asked where the nearest town was. Ten kilometres, they said. Clearly they wanted a ride. I indicated the mud and the hopeless situation. They motioned that the three of them could push until I got over the ridge. It looked impossible. There was a stretch of deep mud where they would have no footing.

No talking it over. They immediately positioned themselves, and I hopped in the van, tried to drive forward. Miraculously, they kept pushing the whole time, even on the precarious slope of the ridge, and the van soon skidded free. I got out, we shook hands, backs were slapped heartily, and they all repeated, "dobro, dobro, dobro!" (It's good!). Of course they were delighted, since it meant a ride into town. In a token gesture of courtesy, they each wiped their boots in the mud, as though on a doormat, before stepping into the VW. Once in Travnik, they offered to buy me a drink.

The Mosque of Esma-sultanija stood for nearly 250 years in the heart of Jajce. It was the town's finest structure from the Ottoman period, and one of the last domed mosques built in Bosnia. It was intentionally destroyed during the war after Bosnian Serb forces occupied the town. All fragments were removed from the site and transported to an unknown location. Also targeted were an adjoining Muslim school, a fountain with an eight-pillared wooden canopy, and gravestones.

The Bosnia-Herzegovina Commission to Preserve National Monuments declared the entire complex a national monument in 2003, and work began on its reconstruction. To date, due to lack of funds, the reconstruction of the mosque has not been completed.

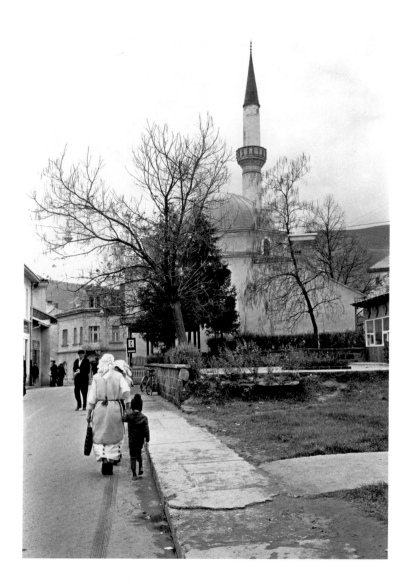

Mosque of Esma-sultanija, Jajce, 1970

Same street with mosque site, Jajce, 2003

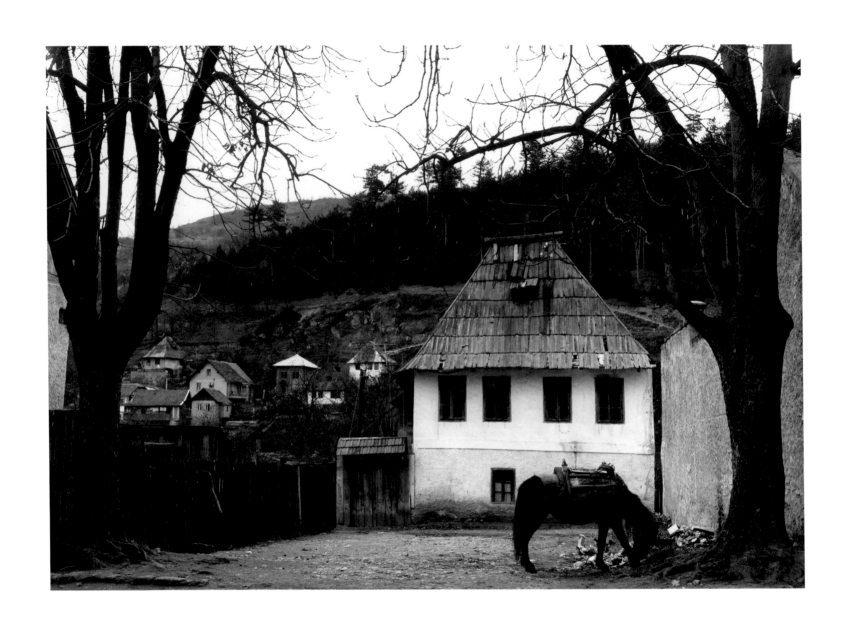

Muharem's house, Jajce, 1970

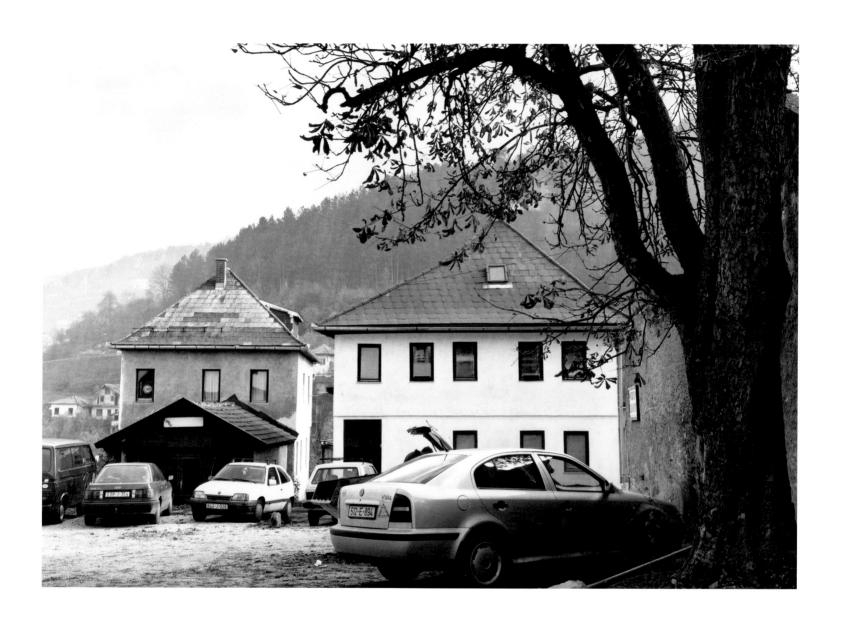

Muharem's house, Jajce, 2003

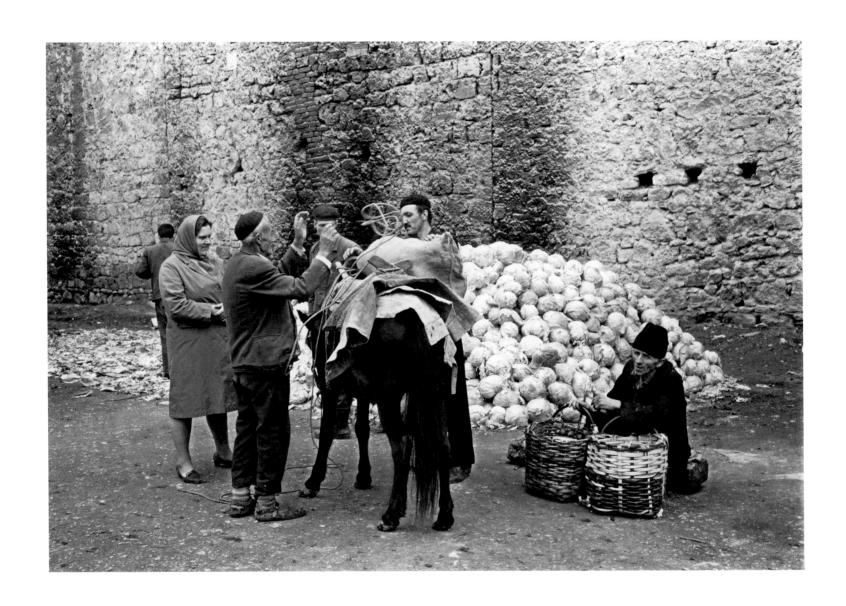

Selling cabbage at the weekly market, Jajce, 1970

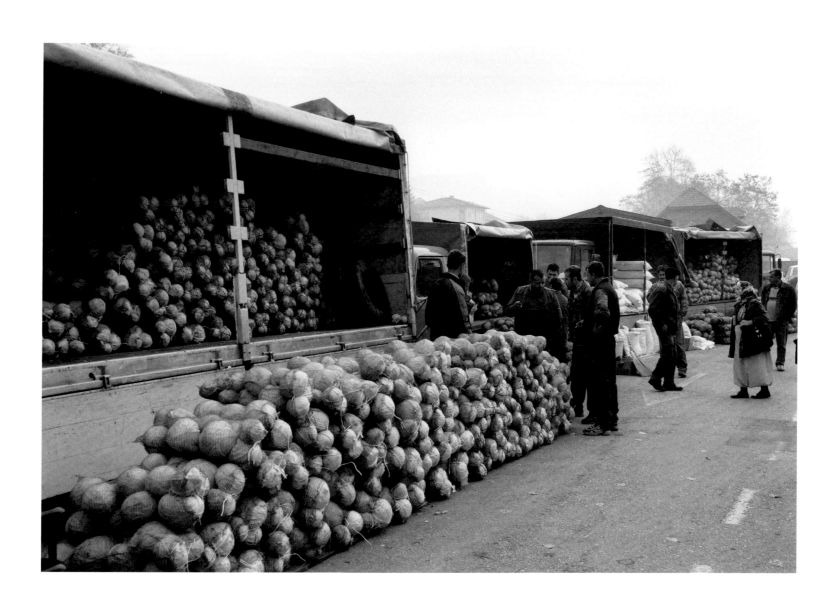

Selling cabbage at the weekly market, Jajce, 2003

IN SEARCH OF PEOPLE

Journal notes: 16 October 2003

It's my last night in the darkroom before I leave for Bosnia. In the red glow of safelights, I sort negatives taken years ago in towns I will soon revisit. Black and white images appear in the developer tray. As they do, memories from my travels return more clearly. A print catches my eye – children playing on a narrow street. In the distance a small village sits in the hills. The image is very sharp. What if I enlarge the picture, so the children's faces become more recognizable? It's late, but I am about to open a door that may help me find people from long ago. So I locate the negative, and raise the enlarger up high.

To prepare for my return journey to Bosnia-Herzegovina in 2003, I turned to materials from my 1970 visit. I had dated each page of my negatives from that trip, adding the name of the region in which it had been taken. I also still had the maps I had marked and the journal I had kept. Over the Internet, I tracked down an old copy of *The Companion Guide to Yugoslavia* by J. A. Cuddon, an invaluable resource in 1970-71. For several days in the spring of 2003, I secluded myself away with these, a good magnifying glass, and a light box. As I retraced my original route and matched my photographs with it, pieces of the jigsaw began to fit. At moments I felt disoriented, poring over negatives from another time and place; but I was on a path, and kept going.

One photograph, of a high school class in Travnik, needed no further identification. The studio that had taken the original picture (the Foto Hazim Studio) had also printed the town name, as well as the names of most of the students. Now, as I looked at it again, I hoped it would lead me to at least a few of the people.

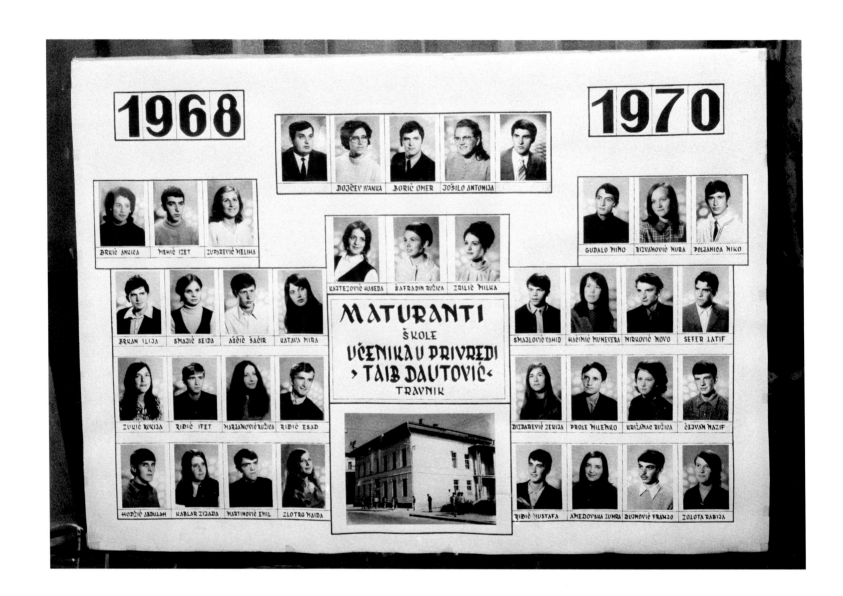

Class picture in shop window, Travnik, 1970

Travnik lies in the Lašva River valley, surrounded by mountains. Headquarters for the Turkish viziers who once ruled Bosnia, it also became a trade, craft, and diplomatic centre. The old town has many wonderful Turkish-style houses and mosques. It was also the birthplace of Ivo Andrić, 1961 winner of the Nobel Prize for Literature.

The city was on the edge of the front line during the 1992-95 war. During that time thousands of refugees arrived from other parts of Bosnia. Combatants heavily mined the roads and hills around the city, and major mine-removal operations were still underway when I returned in 2003.

Over the years I would look at the faces in the school photograph, and wonder what happened to these young people. On my return I found two of the students and a teacher, Omer Borić. One of the students, Franjo Dujmović, loves old photographs and we made a special connection. His own family albums contain many fine images.

One evening his wife made special Bosnian cake, and we drank strong coffee and apple brandy. Franjo pointed at each face in the school photograph and shared updates about most of them. At least six were dead. Some of the others were still in Travnik or nearby towns.

As for Franjo, he has been a shoemaker for many years. Before the war he was also in a travelling folk-dance group, with his wife, Marija. His whole family loves to tell jokes, and Mario Jovišić, my translator, only occasionally managed to stop laughing long enough to translate.

OMER BORIĆ

This picture of the school class looks back on a beautiful time. It takes me back to when I was young. I was a teacher of these people, and I can remember every one of them, but I don't know where they are now. These students liked and respected me. It was a very beautiful time. I was 25 years old and I had all that I wanted.

The situation, with the war, was very difficult. War is war. We have to start over, and hope there is a better time coming. If God is willing, it will be better.

FRANJO DUJMOVIĆ

I was born 1952 in Koričani, near Travnik. I lived in that village until 1960 then I started school in Croatia in a place called Virje. I came to Travnik in 1968 for technical high school. That's where the class picture was made.

One memory I have from childhood: The first time I went to Zagreb from Virje. I came from a mountain village where there was clean air and in Zagreb there were still old smoky trains. It was terrible. I thought I would stop breathing.

I started taking and collecting photographs as a young child. When I look at old pictures, memories return and it's a great feeling when you have something like that, to remember some old things because the picture is saving that past. All my pictures are family memories, friends and dear moments. Every year I collect them together. I was a member of the folklore society, dancing in costume. Young people before the war in Yugoslavia would travel a lot and I also took pictures of all the trips.

I met my wife at folklore dancing. We were married in 1976. Josip was born in 1977, Josipa in 1980. I was here before the war, during the war, and I am still here.

Before the war I had a good secure job. Now I'm still working, but I wonder will my pay be on time and will I have my job tomorrow. I can't feel safe now about having steady work.

In the wartime, our family stayed alive by keeping a sense of humour. One must be born with humour. Because of humour I don't have grey hairs like you do.

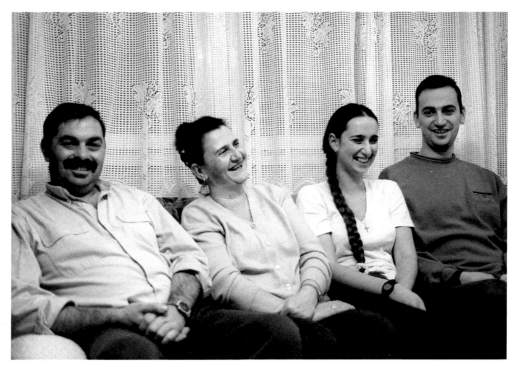

left: Omer Borić, Travnik
right: Franjo Dujmović and family, Travnik (all 2003)
In the class photograph on page 92 Omer is top centre and Franjo is bottom right

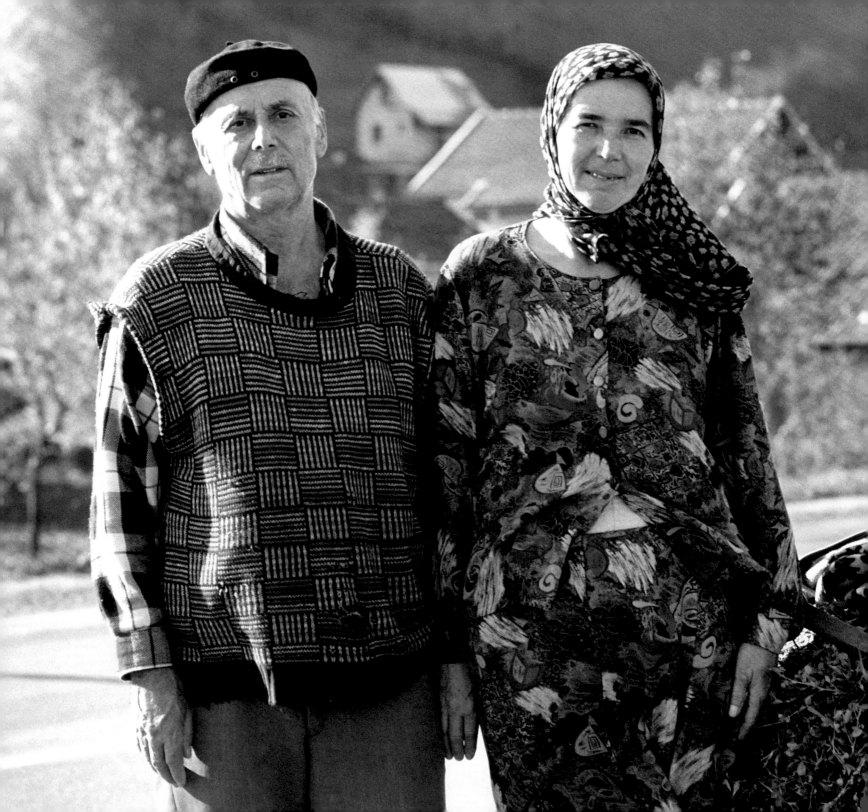

I met Melisa and her parents on my way to Travnik and Jajce, when I stopped to take a picture of their village. Her father and mother, Enes and Šemsa, had been out cutting clover for their cow. They invited me in for coffee and biscuits. Melisa spoke English quite well, and took great pleasure in translating our conversations. Her own words moved me the most.

My name is Melisa, I live in Kakanj, I have 22 years.

I have good parents. I'm very lucky to have them, because they're very special. They give me what money can't buy. I'm rich just because I have them. I can't explain how much I love them *(laughing)*.

Later she wrote:

My parents taught me not to look at nationality, religion, race, and wealth.

They taught me that there are good and bad people, and not rich and poor.

They taught me that I have to be brave no matter what happens, and that life is hard.

They taught me to have compassion for other people and to try to feel how others feel.

They taught me to respect others and to be humane.

They taught me all of human worth.

My personal hope is to finish University and be able to give my daughter the chance for a good life and a good school. For my country, I want more jobs for people without them, more homes for people without them, more food for hungry people. I wish I could make all the world better, to make people happy. I wish I was in a position for that. But I'm just a simple person and I can't do so much. But what I can make better is my life, and I do it.

Enes and Šemsa, Kakanj, 2003

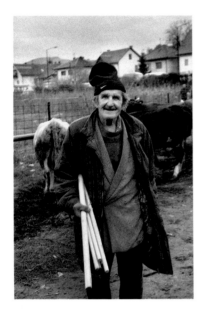

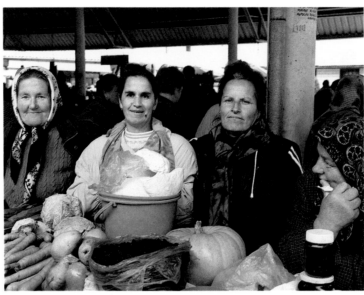

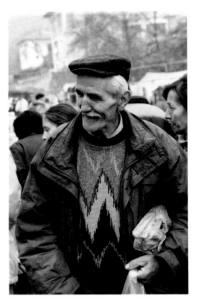

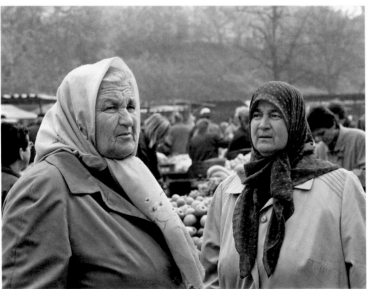

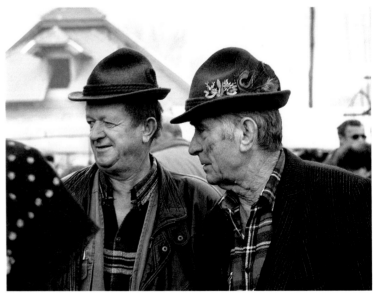

top left: Selling handles, Turbe; *top centre:* Travnik market; *others:* weekly market, Jacje (all 2003)
right: weekly market, Turbe, 2003

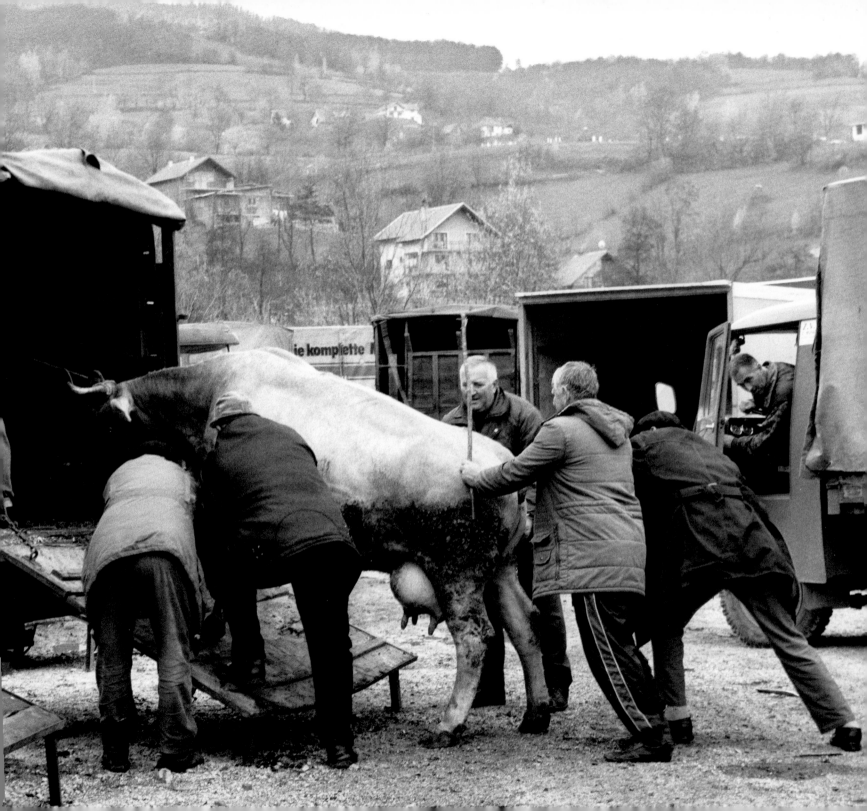

At times my return to Bosnia created a momentum that swept me along as an observer of events, not an initiator. Wednesday, November 5, 2003 was one such day. The night before, a young man had approached me at a Travnik Internet café and introduced himself as Erzad Grahić. He had heard that I was in need of a translator. I hired him on the spot.

At 7.00 a.m. the following morning, we headed to the weekly market in Jajce, a town about one and a half hours away. Along with everything else, I took multiple copies of several of the photos from my first trip to Jajce. On the way, we stopped in Donji Vakuf, another weekly market that I had photographed on my first trip, though this time I missed it by a day. I re-photographed the spot – now more built up, but with an unchanged mountain backdrop – from the original viewpoint.

We reached Jajce, still shrouded in morning haze, and found the market. I photographed and made recordings. Then we showed people my old photographs, hoping to locate the sites and even the subjects. A small crowd gradually formed around us. Lively conversations began as photographs were passed around. One man broke into tears at the remembrance of what the war had destroyed. Jajce had been heavily damaged. With occasional heated debate, the onlookers soon identified most of the original locations. Market goers old enough to remember the more obscure images were summoned as they passed.

To my great disappointment, no one recognized the children. But someone identified one of the adults as Safet Žuna. Another had seen Safet's brother, Džemal, in the market that day. In short order the crowd located Džemal and introduced us. I took a picture of him. When Džemal said that Safet too was somewhere in the market, another search party was formed.

A short time later, a different group produced Tvrtko Zrile, a town historian glad to see my photographs. He too knew the locations and offered to take us to them. As we prepared to join him, Džemal appeared with his brother. Safet was delighted to see the picture and the details it contained. He held the photograph showing his younger self – captured at the same weekly market where I now photographed his older self three decades later. It was like looking into a series of mirrors – past and present combined.

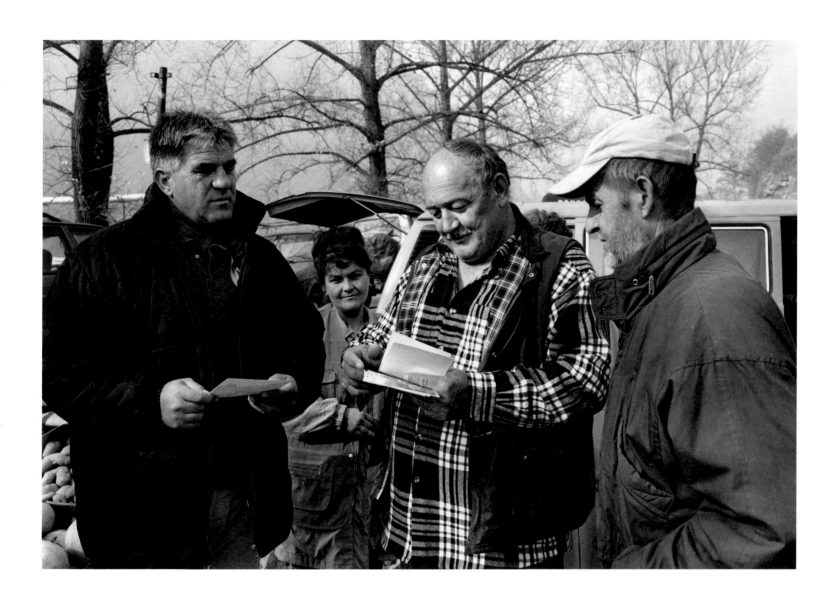

Weekly market, Jajce, 2003

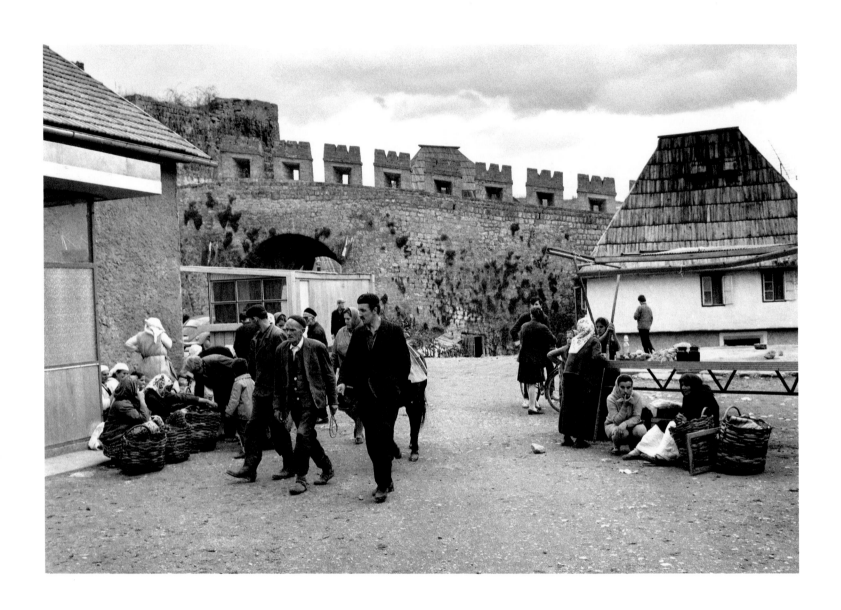

Safet Žuna (in front), at the weekly market, Jajce, 1970

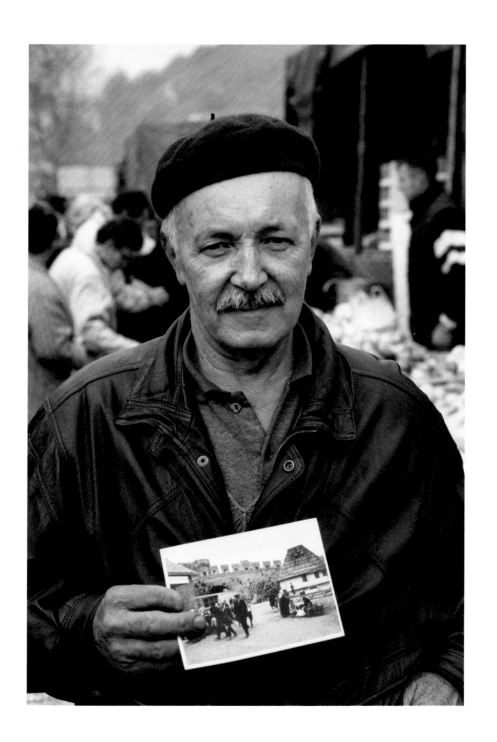

Safet Žuna, Jajce, 2003

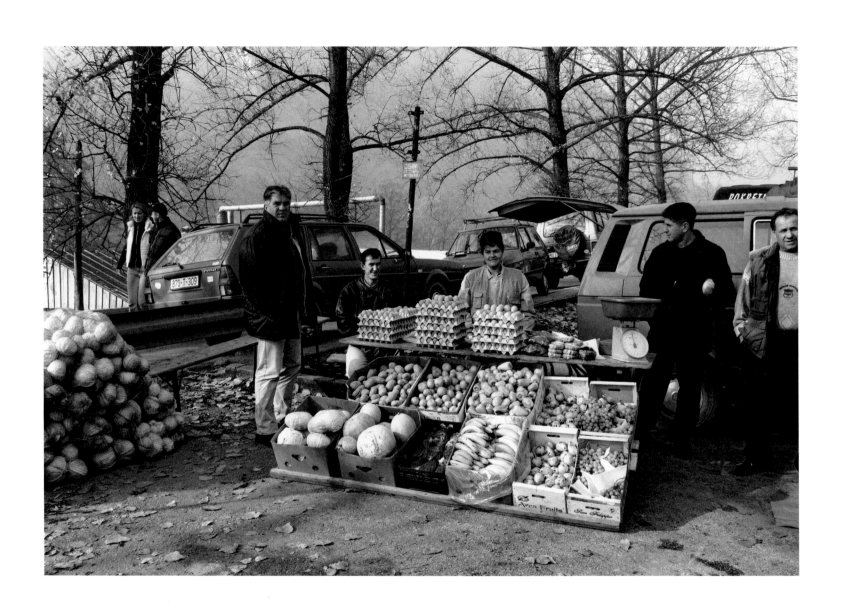

Weekly market, Jajce, 2003

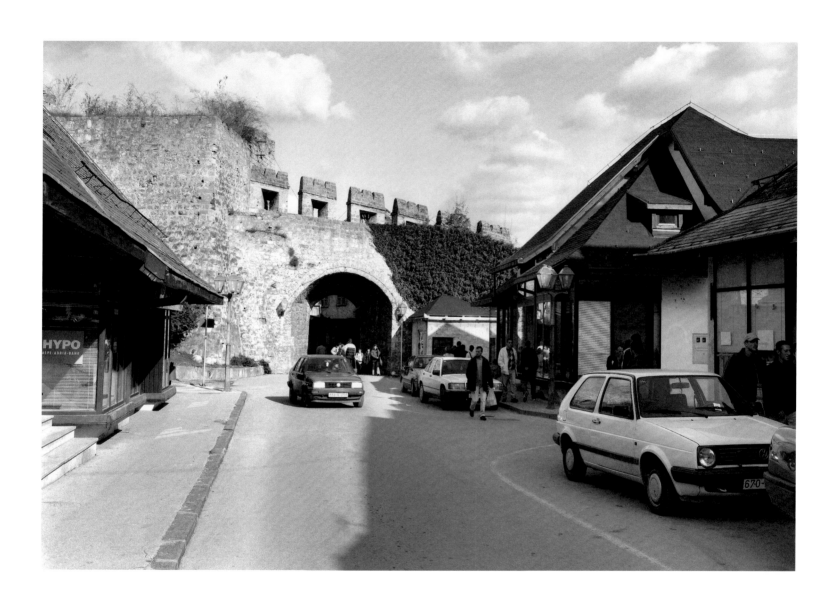

Former market site (on page 102), Jajce, 2003

It was early afternoon now in Jajce. The euphoria of locating a person from the past swept us along. The historian Zrile was waiting to guide us around, and we set off with him.

First he showed us his collection of photographs and cards of Jajce. He also requested copies of my earlier pictures. When I asked him which ones, he said all of them. Fortunately, I had some extra prints.

During our visit Zrile spoke candidly of the war's devastation of human lives and its destruction of the historic buildings and monuments that had once defined the city. When we visited sites I had photographed, some were virtually unchanged, but others had been targeted and completely destroyed during the war.

Muharem Džafer joined us at the final location, where his traditional-style Bosnian house with its distinctive tent-shaped shingled roof had once stood. I had sold photographs of his home and a nearby horse at a Bosnia fund-raising event in 1994, never imagining I would one day meet its owner. I now re-photographed the same spot, where a large modern house and cars had replaced the old house and horse. A tree's distinctive branches and a hillside behind confirmed its location (see pages 86-87). Muharem was happy to see his much-missed home. I gave him a print. He looked through the other old photographs but didn't recognise any of the children, though he did know the location and suggested we talk to someone who lived there.

We said farewell to Tvrtko Zrile and followed our new guide up a steep path toward a castle on a hill overlooking the city. The morning haze had burned away and sunshine lit the stones of the massive castle walls above us.

At the base of the castle we stopped at a small house with a picket-fenced yard. Muharem entered the yard, knocked on the door, and disappeared inside, soon emerging with Sedjad Ćiva. He greeted us warmly, studied the pictures of the children, and smiled broadly. Erzad translated: "This picture shows my sister playing with her friends on the street below. She is here, inside the house now."

Erzad and I looked at each other in amazement. My thoughts were racing.

Sedjad went back inside and we heard him call out. No one appeared for about twenty seconds, which felt like forever; then Šefika Mehanović appeared. After quickly relaying the story, we showed her the photographs. Her resulting laughter, surprise, and elation were unforgettable.

Šefika knew all the children. They were best friends in those days. She asked to have the photograph. "Yes, of course." A minute later: Can she keep this photograph? "Yes, definitely." Then, in another minute: It's okay if she has this photograph? Former strangers shared an unforgettable moment with wistful sighs, laughter, and

Šefika and Sedjad's hearty, emotional voices. In the background were barking dogs, a gusty wind, and the shouted questions of curious neighbours. We talked awhile. I gave Šefika the picture with her young best friends, and Sedjad a print of his childhood home. He offered to take us to meet one of the other children, Vernes (Jef) Kajmo.

Jef was not home, but he returned just as we started to walk away. We produced the pictures – it was unmistakably him. Even his hair had the same contour as years ago. Once again Erzad and I looked at each other. Jef and his wife, Velma, in high spirits, invited us in for coffee. They told us about the other children in the photographs. Samir Basić had moved to Sweden when the war began; Senada Del Ponte to Switzerland. Coincidentally, the weekly magazine *Slobodna Bosna* had just published an article about Senada, which described her wartime work at the Jajce hospital and her determination to complete a medical degree at great peril. It also detailed her life in Switzerland. I later learned that – like the others – she had no photographs of her childhood. Jef had contact information for Samir and Senada.

Senada grew up in Jajce, and was a medical student in Banja Luka and Sarajevo when war broke out. She then worked as a volunteer at the local hospital in Jajce. Many of the wounded were her fellow residents. A former classmate died in her arms after a grenade attack. Later, Senada volunteered to go to Switzerland seeking hospital supplies, but Jajce fell to Serb forces while she was away. She returned to Bosnia many times during the war to visit her parents and brother, and went back to Sarajevo through an underground tunnel to finish her last two medical exams and get her diploma. "When most people desired to escape from Sarajevo, I felt a need to return and finish what I had begun." Today, Senada is a doctor. She lives with her husband and two children in Switzerland, and returns to her home town most summers.

Meanwhile we all wondered, 'Who was the girl with her back to the camera?' A month later, Senada solved the mystery: it was Šefika. The girl we had first identified as Šefika was, in fact, Jef's sister Aida, who returned to Jajce after the war with her husband and son.

Erzad and I had to return to Travnik that evening, but Jef and Velma invited me to stay with them when I returned to Jajce a few days later. We thanked them all and began the drive back, delighted and dazed by the intensity of the day. Together we witnessed the power of photographs to connect, in a place where so many reminders of the past had been destroyed.

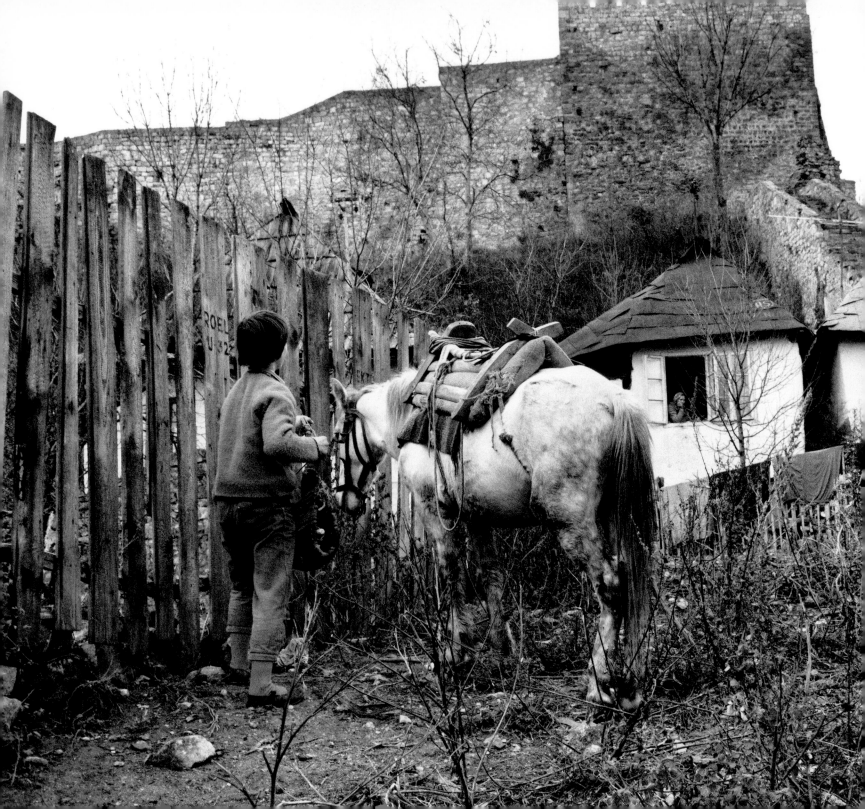

Stari Grad, Jajce, 1970
Sedjad and Šefika's mother leaning out the window of their childhood home
The medieval castle walls rise behind

Farmer's daughter delivering milk, Stari Grad, Jajce, 1970
The whitewashed walls of Jef's house appear on the far left

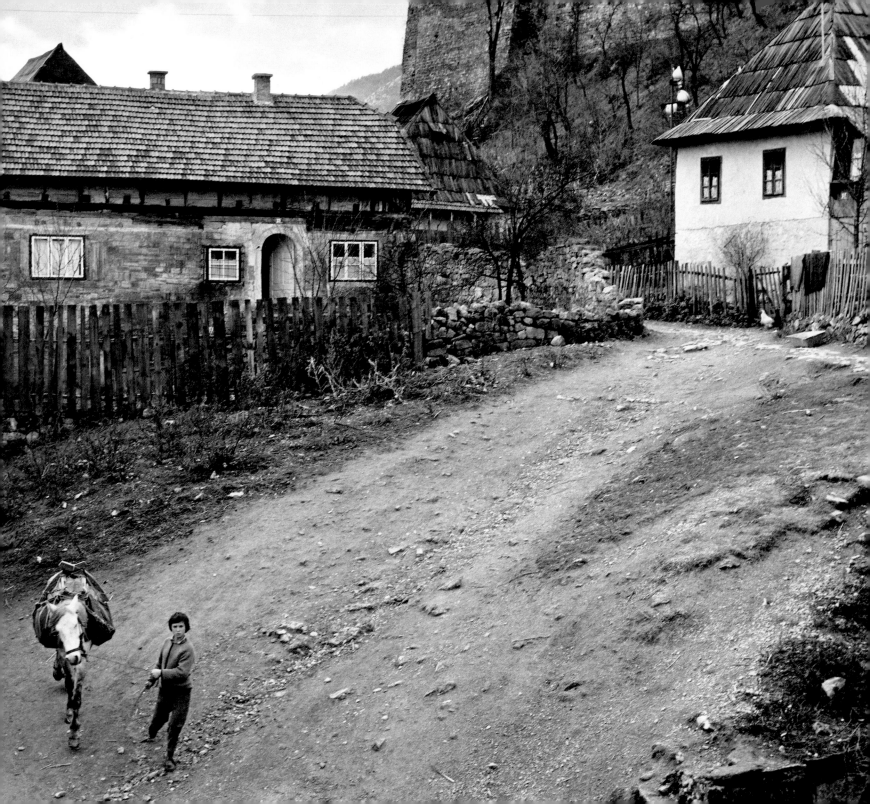

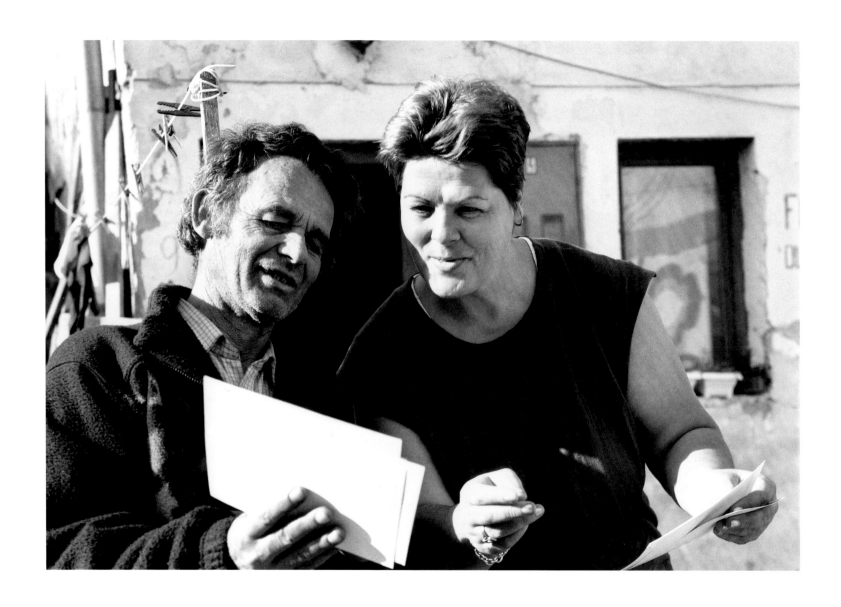

Sedjad and Šefika
Jajce, 2003

ŠEFIKA

These pictures bring back memories from my childhood. I think I was five years old when they were taken. I remember these friends. We had a nice childhood and real friendships. Now we have all gone our separate ways and do not know much about each other since this horrible war. I would like to see them again if it's possible. I would really like to have this picture. I don't have any. I can show my daughter when I was young (*on the verge of tears*). Can you give me this picture? You can write the year you took it on the back. (*Repeating softly*) thirty three years. We were best friends. I am really surprised that something like this happened. I can't describe this moment.

It's nice to see this house again, too. They used to make houses in this style, and everybody is glad to see this old Bosnian style, because houses are now built from different materials.

Life here in Jajce is very hard. Food, wood, electricity, and everything else basic for life needs to be paid for and there is no work. Bosnia is a beautiful country but it is really hard to live here. My husband, Salih, gathers scrap steel and iron to sell. Today he earned 10 marks. It's a difficult time to live.

SEDJAD

I'm surprised and I'm very glad to see these photographs. I was twenty four years old when you took this picture of our old home. And I thank you. We will be friends. I am now hoping to see this photograph in my house. I could cry now, looking at these pictures.

ŠEFIKA

During the war I was a refugee in four different towns. I was here when the war started. Then after Jajce fell to the Serb forces, I went to Travnik, then Gornji Vakuf, Livno, and then Zenica. During the war I was the only person who lived up here, in the grenade shelter, with my sister and her two-year-old son. No electricity, and completely alone. Everyone else moved. We spent all the time in the shelter. Salih was on the front line and at four in the morning on the day that Jajce fell, my friends came and said to me: "You need to run" and at the last moment we left.

In the shelter there was no food, no water; it was terrible. We were more hungry than thirsty. We were under attack and being fired at. We had to get water from about one and a half kilometres away. We went to get some and suddenly we were under fire, so we found a place to hide, left the water, then waited for night and brought the water back.

My sister, her husband, and son now live in Tuzla, and her son is in eighth grade in school. I came back to Jajce again with my family in 1998.

SALIH

During the war there was no food, no water; people were constantly under fire, and our lives were miserable because we were refugees. Now we are here, but we have no jobs, so it's a little bit the same.

At four in the morning when Jajce fell and everyone fled across the mountains to Travnik, no one knew where their families were. It was complete chaos. After two days I found my wife and daughter in the woods and helped them get to Turbe, near Travnik. I am from Livno, a Croat city today, and in those days it was also Croat. I took my wife and daughter there. Then I was taken prisoner and put in a camp. My wife and daughter were going to be sent to Mostar, but because I was from Livno she was able to stay there. Those who were sent to Mostar that day all died, so they are lucky to have survived.

After the war we went to Zenica, a place already overcrowded with refugees. That was a horrible experience for our family, so in 1998 we came here and stayed in the old house near the castle, two years with no electricity or water until the Dutch government repaired the house.

So all those children who were in the picture a long time ago, every one of them faced ordeals in the war, everyone went their own way and each has their story about the war time and it is not a favourable story.

It's good that you are now able to compare life in the 70s when we were all children with life here now. And you will always be welcome here.

Šefika, husband Salih, and daughter Paša, Jajce, 2003

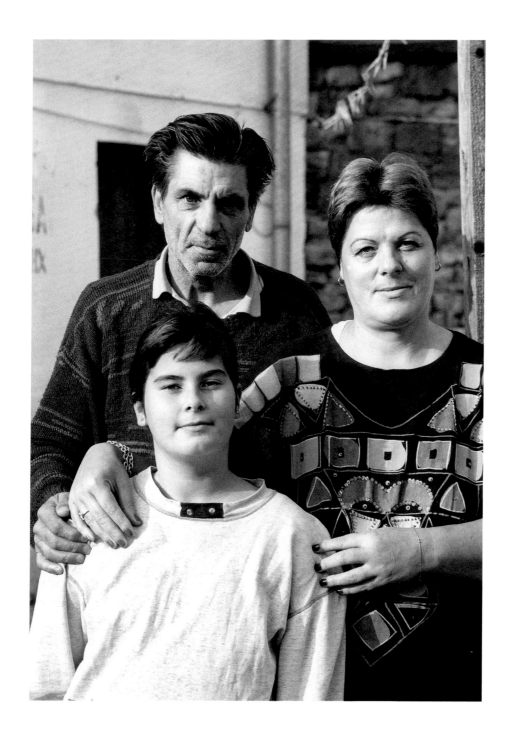

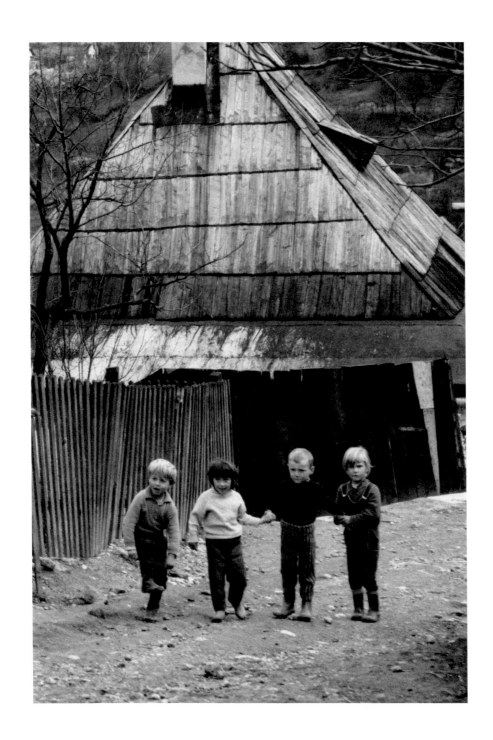

VERNES (JEF)

My name is Vernes Kajmo. Memories from my childhood are excellent. Old things, friends, friendships, going way back. My sister says I look like her five-year-old son. I see that I looked the same as he does today, in this old photo of me and my friends. I can remember one time I hit Senada on the head. Because of that she got smart and became a doctor (*he laughs*).

That was Senada's house in the back, and Samir's house beside us. Everyday I was in front of these houses. I still walk there on the hill every week with my daughter.

I was in the Bosnian army from 1992 to 1995. When my wife was eight months pregnant, I stepped on a land mine and lost my foot. Forty days later my daughter was born and the war ended.

I would like to get together with the others in this picture so we can take this again, in the same place. This picture I will frame and put on my wall.

SAMIR *(Writing from his home in Sweden)*

It's hard to remember details of that day in November 1970, but we had routines of play and I think the four of us children were holding hands in some kind of friendship of the street. If I can unfreeze this frame and imagine the scene happening, I think when I saw a stranger with a camera it was important for me to impress someone who just happened to walk by, so I decided to break a piece of wood with my knee.

Within the confines of ordinary life, growing up in Jajce was great. Those years were very hard in everything regarding material things, but not spiritual, which fulfilled our souls with positive energy. That part of town where we lived was called Mahala, and there were some children about the same age and a few older, but mostly adults lived there. I remember that summers were really hot and we would go on the river Pliva. In the winter we would have a lot of snow and we would ski. That must have been one of the best times of my life.

I hope that Jajce is respected in the way it deserves, for its location, its unique surroundings with so much natural beauty, and, in the end, for the people who live there. Bosnia is one of the most beautiful parts of the world, where different civilizations and religions meet. I wish that people will get along better as time goes by now, and I wish for a world without war, with a lot of happiness and health. For my children, I hope that they can have the life of a normal person.

From left: Samir, Senada, Jef, and Aida, Jajce, 1970

Stari Grad, Jajce, 1970
The children playing in their Mahala (neighbourhood)
Šefika is the girl wearing a skirt

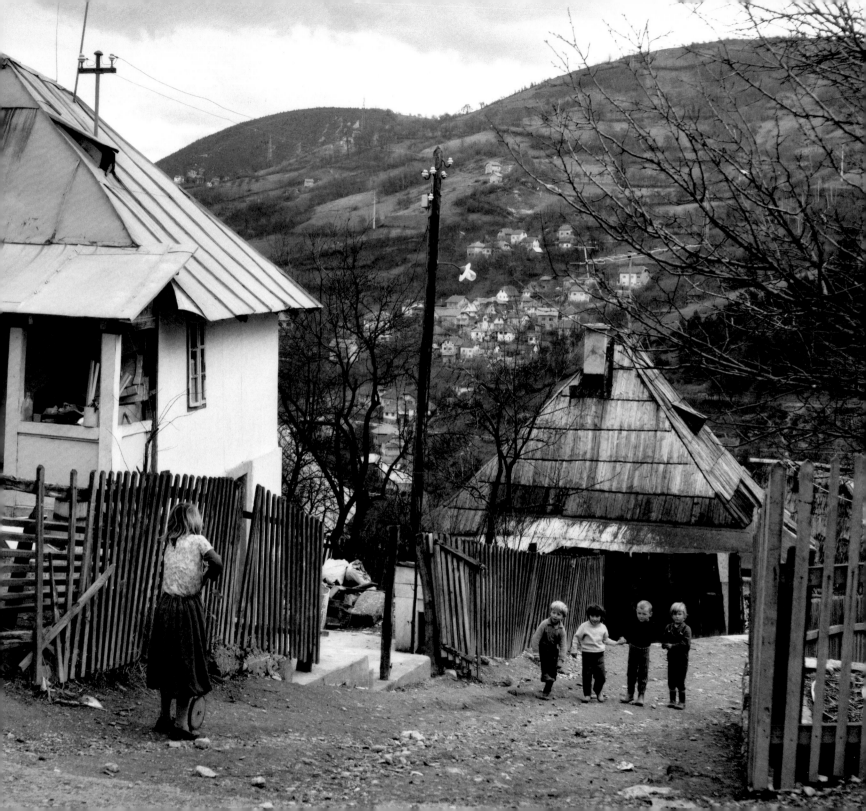

SENADA

I always believed I was born to live a beautiful life. Most of the time I have lived it to my expectation, but there were times when I was unable to see all that beauty. The beauty that is simply there for its own sake, that engulfs you with such happiness and makes you feel fully alive.

The fax I received from Steve Horn last year brought tears to my eyes and reminded me of that universal beauty of life. This man, from a distant land and different cultural background and way of life, invested huge energy tracing children from a photograph he took more than three decades ago when I was five. He wanted to share it with us, and hear our stories.

A predominant image of the place of my childhood is one of vast green meadows on the slopes of the egg-shaped hill that gave the name to the city, Jajce. Those meadows, painted with clouds of wild violets, spread an enchanting scent I still remember. No other place in the world has such beautiful violets, and there was never a better time to be a child. Growing up in Jajce was a tremendous privilege. Dating from ancient Roman times, it was once the capital of the medieval Bosnian Kingdom. Our house stood within the walls of the old castle, once the home of the Bosnian King, who carefully chose this place for its natural advantages: hilly scenery; two beautiful rivers – the Pliva, the first one, flowing into the Vrbas and creating a waterfall within the city; two lakes; and many mountains and skiing terrain, sometimes hidden from a stranger's eye.

With its rich history and breathtaking natural beauty, this place was the heart of our dreams and play. It is no surprise that many of us children developed exuberant imaginations and feelings of blissful happiness and inspiration for adventurous games and play. We feel destined to carry with us the beauty of our childhood always, wherever we are and for as long as we live.

You may ask, 'How can I feel this way about a place that looked in the photo like a poor village?' But you would not wonder if you were brought up on stories of courage, self-reliance, justice, nobility, care for one's family, friends and neighbours; stories of a love, common to us all, for our city and our country. And you would not wonder if you had spent countless days playing freely in the old castle, whose two thick enclosure walls leading downhill were like strong arms hugging the old part of our city.

You would feel then, as we did, like royalty. We even elected our Queen, my sister, who ruled honourably and justly from her medieval throne over her devoted subjects, a group of ten children growing up in our street, Mahala, at the time.

My family home lies within the enclosure walls in the very centre of the old Kingdom, close to the castle. Built centuries ago, our house, like Jajce, withstood enormous changes over time. With its thick outer walls and hipped roof and attic, our charming, double-storey house resembled the old castle. We remember our parents' preparations for winter provisions, and the smell of the freshly smoked lamb, beef, and cheese in the attic. The house remains in memory an oasis of love, peace, and safety for my siblings and me.

Though we lived in the middle of the city, we always had a big garden, surrounded by a flowerbed with beautiful roses. My parents grew organic vegetables: potatoes, tomatoes, carrots, onion, garlic, parsley, capsicum, corn, and kidney beans. Along the timber fence were fruit trees – apples, pears, walnuts, and even peaches – carefully chosen and cared for by my father. Plum trees gave us our homemade 'sljivovica' – plum brandy. That timber fence, old and worn out in the year the photo was taken, still protected our property and privacy.

But protecting property and residents was a neighbourhood affair in those days, and privacy was not as important. Our gate and the door to our house were always open, and guests were welcome to a traditional cup of coffee, some sweets or a soft drink, even a meal. Everyone watched not only over their own children but those of their neighbours as well.

Deeply engraved on my memory are days when our mothers joined us in our play. I liked watching them running with us, laughing, jumping on a skipping rope, while our boys conquered the walls of the old castle, climbing to the top. I will never forget how little we needed to be entirely happy.

Then cruel history, like a plague, plundered the countries of the Balkan Peninsula and brought destruction and devastation to my city and my beloved Mahala. Even ten years after the conflict, the scenery is gloomy. My charming old family house, renovated and sparkling in the decades before the war, was bombed and destroyed. The roads around the old castle were destroyed as well. Most important, many neighbours were killed or forced to flee the city.

My family somehow managed to survive, though we continue to suffer in many ways. Members of my Položanin family separated and now live on three continents, instead of in our once idyllic neighbourhood.

My ageing parents live in a foreign country, where they do not speak the language and are homesick. They dream of going back to their land and rebuilding their house. With help, they have managed so far to erect the walls of the ground floor.

But it is unlikely they will ever see their dream come true. My father is not likely to have the chance to welcome his children and his grandchildren to their parents' and grandparents' home, and to enjoy the echoing laughter of the new generation of the Položanin family.

So the photo of me as a five-year-old girl, with my childhood friends and neighbours, wakened memories of happy, joyful and carefree childhood days spent in the warmth and safety of my parents' home. It brought back the sound of children's laughter echoing in the streets of a place that has endured many changes since 1970, good and bad alike.

Translation by Jasmina Položanin Kesić

The place where the children stood in the old photograph. Their houses were destroyed in the war. Jajce, 2003

Jef and his daughter Nadja, Jajce, 2003

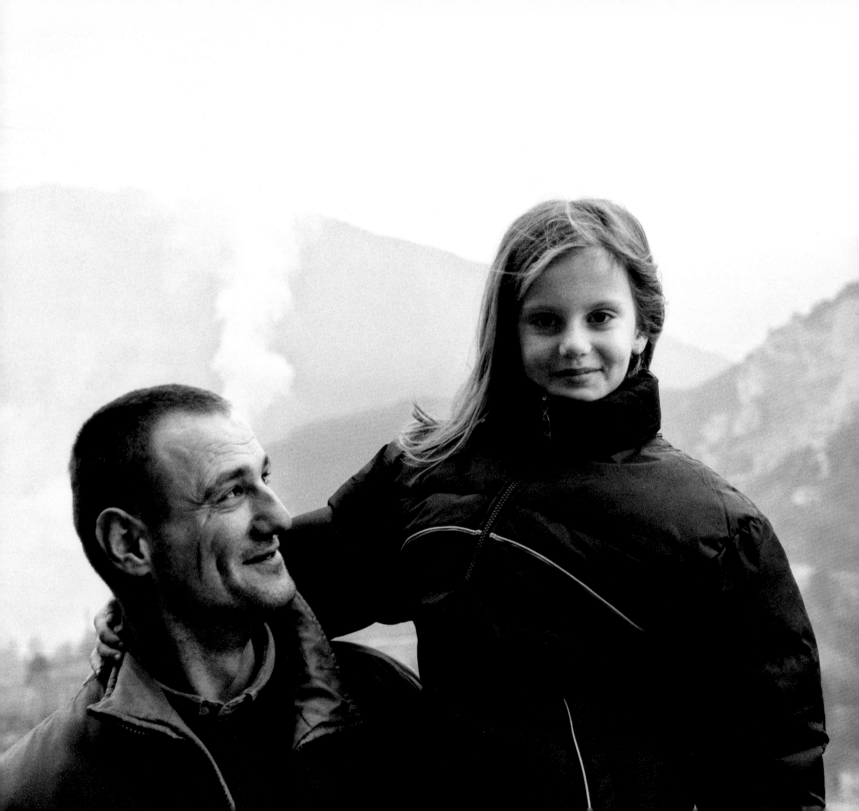

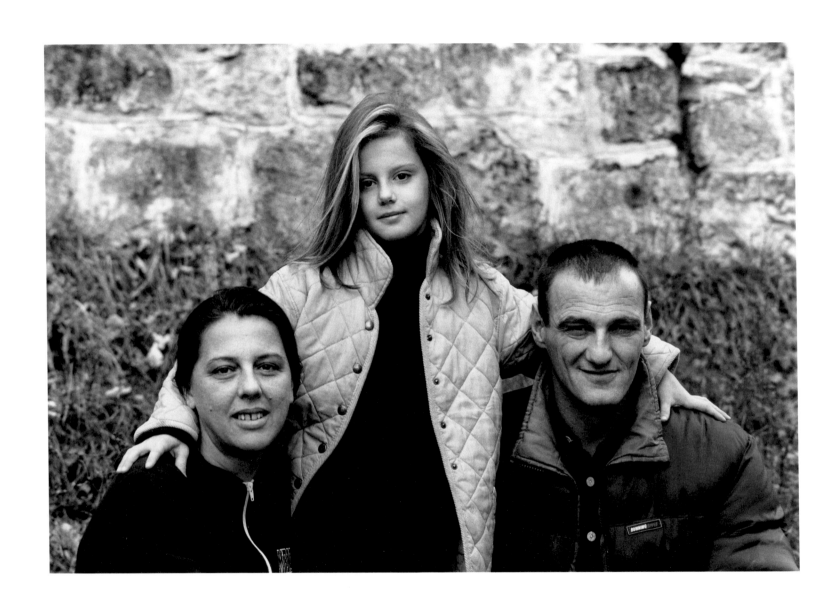

Jef with Velma and Nadja, Jajce, 2003

Journal notes: 9 November 2003, Jajce

For the past two days I've stayed at the home of Jef, Velma, and Nadja in Jajce. I am still awed that one click of a shutter, perhaps 1/125th of second, led me to them. We have communicated by dictionary, gestures, Bosnian, German, English, pantomime, and much laughter. Nadja has worked hard to improve my Bosnian accent.

Contradictory images are everywhere – architectural diversity in the midst of the devastation of war, natural beauty alongside environmental damage. Across from Jef and Velma's apartment is a school building bombed during the war, a gaping hole still in its roof. Jef takes me down into the catacombs, an underground burial chapel hewn into rock in the 15th century. The dark chambers are cool, damp, mysterious. Nearby are the 4th-century ruins of a temple to the Persian god Mithras, next to a 14th-century bell tower. We walk past a mosque under construction, replacing one destroyed in 1993. We go to Jajce's spectacular waterfall, where two rivers meet in the heart of the town. Forested mountains gather around us. A massive silicon factory spews dense smoke into an otherwise blue sky. The next day we drive to two beautiful lakes a short distance away.

I go with Jef and his friend Edo (my local translator) to visit Šefika, her husband, and daughter. Once again I feel the ancient presence of the high castle walls around us as I learn more about Šefika's life. We also have coffee with a couple from Prijedor in the Republika Srpska, whose son I know in the United States. Time slips by; I try to take everything in.

Too soon I will be leaving Jajce and Bosnia. Many of the people I have met on this trip seem courageous and resilient, having endured unspeakable hardship. Their stories have deepened my understanding and my yearning for peace, for reconciliation. I will carry away the brightness of new friendships with Jef, Velma, and Nadja, and others in Jajce, Travnik, Mostar, Sarajevo, and places in between.

MOST

Biti ogroman
isklesati iz kamena sedlo
staviti ga preko rijeke
zajahati rijeku
i
kroz polja naranče
polja lavande
kroz vinograde
ujahati u more

Irfan Horozović was born in 1947 in Banja Luka, Bosnia-Herzegovina
He has published poems, short stories, plays, and several novels. In 2003 his novel *William Shakespeare in Dar es Salaam* was awarded the
Mesa Selimovic prize for the best novel in the regions of the former Serbo-Croatian language. Horozović lives in Sarajevo

BRIDGE

To be immense
To carve a saddle out of stone
Place it across the river
Ride the river
And
Through the fields of oranges
Fields of lavender
Through the vineyards
Ride into the sea

from *Dead Poet's Book*, by Irfan Horozović
translated byTaida Horozović

FIVE HISTORIC BOSNIAN TOWNS AND CITIES

JAJCE

Capital of the medieval kingdom of Bosnia, Jajce is renowned for its ancient fortress set on top of a conical hill, with the steeply pitched roofs of the Old Town spread out on the slopes below. At the foot of the hill one of the most spectacular waterfalls in Europe plunges into the River Pliva. With its intact city walls, Jajce is one of the best-preserved medieval towns in the Balkans. Its roots go back further: one can still visit the remains of a Roman temple to Mithras. First mentioned in 1396, Jajce became the seat of the Bosnian kings. In 1463 Bosnia fell to the invading Turks, and King Stjepan Tomašević was captured and beheaded. Jajce was overcome but was soon retaken by King Matthias of Hungary – the last bulwark of Christendom against the Turks, surrendering finally to the Ottomans in 1528. In 1943 the Anti-fascist Council of National Liberation of Yugoslavia under Josip Broz 'Tito' met in Jajce, establishing a new government of Yugoslavia, the basis of the post-WWII socialist state. More recently Jajce was occupied by Bosnian Serb forces in October 1992; its predominantly Bosniak and Croat population fled, and many of its historic buildings were destroyed. For some years after the war the Croat-led local authorities obstructed the return of Bosniak and Serb refugees. The situation has now greatly improved.

TRAVNIK

Travnik sits on the banks of the narrow valley of the Lašva River at the base of Mt Vlašić. The remains of its kaštel, one of the many fortresses built during the medieval Bosnian kingdom, still dominate the town. Under Turkish rule Travnik expanded and, after the destruction of Sarajevo in 1697 during the Habsburg War, became the seat of the vizier (the ruling Turkish official) for 150 years. Many of Travnik's impressive range of historic buildings date from this time. Because it was an important administrative centre on the Western frontier of the Ottoman Empire, France and Austria-Hungary established consulates in the town, leading it to be called the European Istanbul. Nobel Prize-winning author Ivo Andrić, born in Travnik, memorialised the era in his book *Bosnian Chronicle*. In the Austro-Hungarian period Travnik became a centre of wood and textile industries that are still important today. During the recent war refugees from other parts of Bosnia took shelter in the town. Travnik was held by the Bosnian government through the latter part of the war, and many Croats were forced to

leave; the immediate postwar period was marred by a number of attacks on returnees. More recently Travnik was given the official status of a UNHCR Open City in which ethnic groups once again live peacefully together.

SARAJEVO

Sarajevo, the capital city of Bosnia-Herzegovina, blends Oriental and Austro-Hungarian influences where minarets rise alongside elaborately stuccoed Central European-style buildings. It was founded around 1461 as capital of the newly conquered Ottoman province of Bosnia. Sarajevo's golden age was the 16th century, when it was the largest and most important city in the Ottoman Balkans – second only to Istanbul itself. With its Muslim and Orthodox and Catholic Christian population living alongside Jews expelled from Spain who had sought sanctuary in the Ottoman Empire, Sarajevo became known as the European Jerusalem – home to four great religious traditions. The next great period for the city came with the Austro-Hungarian occupation of Bosnia-Herzegovina in 1878. A Western European-style city rapidly grew up alongside the old Oriental one. Culturally and economically Sarajevo flourished until the outbreak of WWI, a catastrophe triggered by the assassination of Archduke Franz Ferdinand in the city in 1914. It was only after 1945, as the capital of a Yugoslav republic, that the city began again to develop with the construction of high-rise suburbs and new industries and the establishment of important cultural, educational, and media institutions. Sarajevo became known for its vibrant cultural life, legendary for its tolerant multi-ethnic character. In 1984 the city was home to the XIVth Winter Olympics, bringing the world to Sarajevo. After war broke out in April 1992, Sarajevo suffered the longest siege of a city in modern times, shelled relentlessly from the surrounding hills by the Bosnian Serb Army. Now largely reconstructed, the city is regaining its place as a cultural mecca for the region.

STOLAC

Stolac was the quintessential synthesis of the Mediterranean and the Oriental, with its harmonious low stone buildings set on the banks of the Bregava. Before the recent war the town was a candidate for inclusion on UNESCO's World Heritage List. The Stolac region has been settled for thousands of years and the locality was a municipal centre in Roman times. Although the medieval fortress of Vidoška sits above Stolac, the town did

not develop until the Ottoman period. By the 15th century it was the seat of a kadiluk – an administrative area ruled by a judge. Stolac was famous for its beautiful residential complexes, built from local limestone and roofed with stone tiles in Herzegovinian style. The loveliest of these was Begovina, residence of the Rizvanbegović family, the most famous of whom was Ali-paša Rizvanbegović (1833-1851), Vizier of Herzegovina. During the Bosnian War of 1992-1995 Stolac was occupied by Bosnian Croat forces (HVO), its Bosniak and Serb citizens killed or expelled, and the town's Ottoman heritage completely destroyed. It is only now being restored.

MOSTAR

Spread on either side of the turquoise Neretva River with the arc of the Stari Most (Old Bridge) thrown across it, Mostar – the economic and cultural centre of Herzegovina – has a Mediterranean feel. The destruction of the Stari Most on 9 November 1993 was one of the iconic images of the Bosnian War; the official opening of its reconstruction on 23 July 2004 was televised around the world. Although Mostar was first mentioned in 1474, the 16th and 17th centuries were the peak of the town's development as hub of Ottoman administration in Herzegovina and a strategic base in its conflicts with Venice, as well as being an important trading and craft centre. During this period such monuments as the Karadjoz-beg Mosque were constructed, as well as the Stari Most (1566). The bridge gave the city its name, mostar meaning 'bridge keeper'. In 1873 the largest Orthodox church in Bosnia was built on a site chosen by the Sultan, who also donated funds toward its construction; it was destroyed by Croat extremists in 1992. With the Austro-Hungarian occupation, a new Western-style city began to develop, spreading over the west bank of the Neretva. Mostar is now a city largely divided between Bosniaks and Croats, although historically the population of Mostar was very mixed, with Serbs forming almost a fifth of the population. With the restoration of the Old Town and the Stari Most, once again tourists are returning to this most beautiful of cities.

Helen Walasek

SELECTED RESOURCES

PEACE, SOCIAL JUSTICE,
AND INTERNATIONAL COOPERATION

*American Friends Service
Committee (AFSC)*
www.afsc.org

*International Fellowship of
Reconciliation (IFOR)*
www.ifor.org

Amnesty International
www.amnesty.org

Open Society Institute
www.soros.org

*A World Institute for a Sustainable
Humanity (AWISH)*
www.awish.net

*Children's Movement for
Creative Education*
www.childrensmovement.org

Karuna Center for Peace Building
www.karunacenter.org

The Advocacy Project
www.advocacynet.org

Nuclear Age Peace Foundation
www.wagingpeace.org

BOSNIA-HERZEGOVINA AND THE BALKANS

The Bosnian Institute
www.bosnia.org.uk

Center for Balkan Development
www.balkandevelopment.org

Academy of Bosnia and Herzegovina
www.academybh.org

Bosnia: A Short History
Malcolm, Noel.
Macmillan, London & New York, 1996

Bosnia: A Cultural History
Lovrenović, Ivan.
The Bosnian Institute/Saqi Books,
London and New York, 2001

The Death of Yugoslavia
Silber, Laura & Little, Alan.
Penguin/BBC, London, 1995

*Blood and Vengeance: One Family's
Story of the War in Bosnia*
Sudetic, Chuck.
W.W. Norton & Co., New York, 1998

Sarajevo: A War Journal
Dizdarević, Zlatko.
Henry Holt & Co., New York, 1994

The River Runs Salt, Runs Sweet
Chesic, Jasmina.
Panisphere, Eugene, Oregon, 2003

To End a War
Holbrooke, Richard.
Random House, New York, 1998

*Bosnia and Herzegovina:
The Bradt Travel Guide*
Clancy, Tim.
Bradt Travel Guides, 2004

Nowhere Man
Hemon, Aleksandar.
Nan A. Talese, New York, 2002

Pretty Birds
Simon, Scott.
Random House, New York, 2005

The Bridge on the Drina
Andrić, Ivo (trans: Lovett Edwards)
University of Chicago Press, 1977

PHOTOGRAPHY AND FILM

Blue Earth Alliance
www.blueearth.org

Fifty Crows Foundation
www.fiftycrows.org

FotoFest Houston
www.fotofest.org

Photolucida
www.photolucida.org

The Nearby Café
www.nearbycafe.com

*Aftermath: Bosnia's Long Road
to Peace*
Book/website by Sara Terry
www.aftermath.com

Back to Bosnia
A film by Sabina Vajraća
www.backtobosnia.com

No Man's Land
A film by Danis Tanović, 2001

Perfect Circle
A film by Ademir Kenović

THE BOSNIAN GUIDES

Erzad Grahić
Travnik and Jajce

Erzad's favourite expression was 'no problem'. He had never translated before but was willing to take a leap, and so was I. He was on a break from the University of Sarajevo, where he was studying criminology. In addition to translating, Erzad helped me record audio segments at the out-door markets. We shared the unforgettable experience of finding Safet Zuna, Šefika, and Jef.

Taida Horozović
Sarajevo

Taida came to study in the United States during the war through the Bosnian Student Project, organised by the Fellowship of Reconciliation. She returned to Bosnia in 1999 and has been active in women's rights, technology and communications management, and work focusing on youth. Her energy seemed boundless. Taida's home town was Banja Luka, now part of the Republika Srpska. Her father, Irfan, is an internationally recognised author.

Mario Jovišić
Travnik

The war began when Mario was in the fifth grade. He described trying to study while grenades were falling and there was no electricity, only candlelight for reading. Like Edo, he learned English through watching movies, listening to English and American songs, and speaking with foreigners who came to Travnik during the war. Mario helped found a snowboard club to provide recreational opportunities for young people at nearby Mount Vlašić.

Edin (Edo) Omić
Jajce

I met Edo through Jef. Their fathers were best friends who had both died before the war. Edo taught himself English by watching movies and listening to songs. He was ten years old when the war started and was a refugee for many years. Edo wanted to go to the University of Sarajevo, but it was too expensive and there were no scholarships. Yet there was little work without a university degree. Jef and Velma later told me that he is a very creative person, an accomplished painter.

Suad Slipičević
Mostar

The Community of Bosnia, based at Haverford College in Pennsylvania, brought Suad out of the former war zone to finish high school in the United States in 1996. His hosts, Warren and Patricia Witte, treated him like a family member. Despite terror and personal tragedy during the war years, Suad was committed to reconciliation and returned to Mostar in 1998, where he began law studies and found work as a translator for the European Union.

ACKNOWLEDGEMENTS

This book was created with the hands and hearts of many individuals. Sandy Bishop, a visionary woman, guided the project; without her I would have lost my way. Wayne and Kiki Martin underwrote critical stages of the project. Their enthusiasm overcame my initial hesitation. Kip and Stanley Greenthal provided retreat spaces, trusted eyes and ears, midnight editing services, and a 24-hour hotline. Longtime co-workers Carol Noyes and Tara Dalton managed the studio during my absences. Mary Jane Knecht, formerly at Copper Canyon Press, offered endless publishing guidance. Janet Thomas, Alice Acheson, and Phyllis Potter at Islehaven Books gave welcome advice and encouragement.

My gratitude also to the following writers and editors: Kip Greenthal, Dorothy Conway, Alie and Oscar Smaalders, Lorna Reese, Richard Ward, Sarah Minifie, and Polly Snyder. When I needed help with translation or yearned for a friendly Bosnian voice, Zaim Melić responded. Other translators included Jan Zehner, Denis Ignjatović, and Alma Dulić. My Bosnian guides – Taida, Edo, Mario, Erzad, and Suad – each picked up where the other left off. I'm grateful for their friendship and for the doors they opened.

Paul Caponigro has provided continuing inspiration. Other photographers helped inspire this book: Natalie Fobes, Phil Borges, Sara Terry, Glenn Ruga, Frank Ward, my brother Stephen Petegorsky, Seamus Ryan, Homer Sykes, and Chris Rauschenberg offered practical wisdom and coaxed the story to emerge. For help with picture editing and sequencing, thanks to Greg Ewert, Meg Partridge, Craig Withrow, and Stanley and Kip Greenthal. Joe Floren, Heather Stansbury, Ruthie Thompson-Klein, and Karla Lillestol contributed design expertise. Judd Boone volunteered web work.

Thanks also to those who helped in many different ways: David Bill, Alex Nellie, Steven Brouwer, Elf Fay, Lisa Geddes, Eric

Hall, Jerome Marshak, Laurie Teichroew, Mearl Bergeson, Nick Binkley, Lisa and Bill Driscoll, Bob and Jean Elliott, Georgie Muska, Barbara Nason, Blaine Harden, Peggy Brooks, and Dana Drake at Panda Lab.

Amherst College sponsored my 1970 trip. Years later, in the spring of 2004, Michael Karp and the board of AWISH took my project under their wing and welcomed me into a larger community. My thanks also to Quintin Hoare and Helen Walasek at The Bosnian Institute for thoughtful and expert contributions to historical material in the book. Thanks also to Damir Pozderać and Leila Rachidi at the Academy of Bosnia-Herzegovina. For arranging contacts in Bosnia, thanks to: Warren Witte, Doug Hostetter, Priscilla Hayner, Emir Pasilić, Dzenita Saračević, and Ernest Jambresić. Thanks to historians, architects, and scholars: Ferhad Mulabegović, Fatima Maslić, Pavle Mašić, Tvrtko Zrile, Enes Milak, Seneša Sešum, and Professor Andras Riedlmayer. And thanks to my Bosnian hosts: Taida and Mike, Jef and Velma, Marijan and Vasvija, and Šaban. Senada Del Ponte, Samir Basić, and Melisa corresponded faithfully. Colleen Smith, editor of *The Islands' Weekly*, published my first Balkan journals; Alma Duroković, deputy Editor-in-Chief at DANI magazine, ran a feature story of my visit to Jajce, the seed out of which the book grew.

And thanks to my publisher, Dewi Lewis, for connecting this work to a larger community.

My parents, Bea, Herb, and Carol, are no longer alive. Each of them cared deeply about peace and social justice. This book carries their spirit between its covers.

Pictures Without Borders would have remained an unrealized dream without the love and encouragement of my wife, Polly Ham, and our daughter, Laurel Horn. I offer special thanks for their support.

To those not named who appear in these photographs or who offered hospitality during my trips; to those who provided valuable support and guidance in other forms – I also offer thanks and gratitude.